IMAGES
of America

THE OREGON
STATE FAIR

ON THE COVER: Oregon governor Tom McCall and his wife, Audrey, cut the ribbon from a hot air balloon to open the 1969 state fair. (Courtesy of the Oregon State Archives.)

IMAGES
of America

THE OREGON
STATE FAIR

Steven Robert Heine

ARCADIA
PUBLISHING

Copyright © 2007 by Steven Robert Heine
ISBN 978-0-7385-4877-7

Published by Arcadia Publishing
Charleston SC, Chicago IL, Portsmouth NH, San Francisco CA

Printed in the United States of America

Library of Congress Catalog Card Number: 2006935601

For all general information contact Arcadia Publishing at:
Telephone 843-853-2070
Fax 843-853-0044
E-mail sales@arcadiapublishing.com
For customer service and orders:
Toll-Free 1-888-313-2665

Visit us on the Internet at www.arcadiapublishing.com

CONTENTS

ACKNOWLEDGMENTS

The author would like to thank the following people and groups:

Oregon State Fair director Dave Koellermeier, fair public relations director Bev Young, and Connie Bradley, business and community development manager.

Former Oregon State Fair director Lillie Ward for making her private collection of photographs available for this book. Oregonians will be forever grateful to her.

Cindy Day for offering her private collection of photographs of L. B. Day at the fair.

Gerry Frank for loaning the best of his own collection of photographs.

Mikki Tint, Megan Friedel, Lucy Berkley, and the Oregon Historical Society.

Ross Sutherland and the Marion County Historical Society.

Kari Rolston and the Salem Library.

Kathy Reeves and Scott Bernards for their work in presenting the Rufus the Bull story.

Tim Backer and the Oregon State Archives Division.

Tiah Edmunson-Morton and the Oregon State University Library. Oregon State University has a wonderful archives department and a very professional staff. And to Stan McQueen of Dallas for his help in my research at OSU. That research led us to the Gifford Collection of photographs taken by the Gifford family.

Merrialyce Blanchard and the State Library. Merrialyce was able to find many pictures of the fair that had not been seen in decades. Her determination was a key factor in preserving those photographs and making them available to all Oregonians.

Scott McArthur, Monmouth author and writer. Also to Ben Maxwell, the former *Statesman-Journal* writer who preserved many moments of Salem history and the fair in his amazing journals.

Joanne Robinson, Janita James, and the staff of the home economics department of the Oregon State Fair.

Salem online history compiled by Kathleen Clements Carlson.

The Oregon State Fair by Barry Branaugh, Dayna Collins, Susan Gibby, LaVerne Marker, and Mark McKinney of Western Oregon University (1976).

John Marikos of the *Salem Statesman Journal* newspaper.

Lastly, I would like to thank Julie Albright and the editors of Arcadia Publishing for promoting this book and helping to lay a foundation for Oregon State Fair history. I hope that under the Oregon State Parks Department the Oregon State Fair can go forward with development of a history project. The Oregon State Fair is the biggest show in Oregon and well deserves to have its history shared and enjoyed.

INTRODUCTION

For nearly 150 years, the Oregon State Fair has been the most important cultural event in Oregon. To understand the fair is to understand the courage, the triumphs, and the joy of so many Oregonians over time. To see the fair is to discover and rediscover Oregon and the people whose energy and innovation drives this state forward.

The history of the Oregon State Fair is really about the lives and the hopes of so many fine Oregonians. I wanted to acknowledge and include them all, every one that participated or contributed to the fair. I was equally as impressed with the tiny moments of the fair, captured in various photographs, as I was with the major moments, like the one on the cover. What is my favorite photograph? I have no answer, but one of them was of a horse trainer, hiding from the camera. Roses for the victorious horse are nearby and the wheels of the horse trailer are covered in empty oat sacks; a wonderful moment, like so many.

Sometimes in the writing of this book, I could only show the major events of a given year. But other times, I tried to go into as much detail as possible within an era. The Lillie Ward years are an example of that. As a one-time secretary for the fair and later fair director, Lillie Ward was by far the best historian that the fair ever had. She did what no other Oregon State Fair director had ever done—she preserved as much as possible about her time there and the people who were part of the fair. A cordial and energetic woman, her era was the glorious age of the fair. Dozens of stars appeared at the fair and wrote to thank her for the opportunity. She also seems to both have enjoyed and endured the formalities of the fair. No other institution in Oregon, outside of the governor's office, has so much tradition and ceremony. I know I included several photographs of Lillie holding silver platters or congratulating winning jockeys, but I wanted those moments to remain forever.

I was fortunate. I grew up in Salem near the Oregon State Fairgrounds. The Oregon State Fair was by far the biggest event of the year in Salem. In North Salem, where the fairgrounds are located, it seemed to be the only event of the year outside of a few school and church activities. The fair greatly impacted the neighborhoods and businesses near it. For us it was a family event, one not to be missed. At the end of summer, with $3 or $4 of berry-picking money in our pockets, my cousin and I could make quite a day of it at the fair. We would scare ourselves to death on a few rides, have a corndog for lunch, and always run out of money before we got into any real trouble.

Included in this work are many photographs of animals—even they felt the excitement of the event. You can see it on their faces and in the way they walk. But again, I was far more interested in the young people presenting their animals than in the animals themselves. That is what to look for in the photographs of animals here. Look for the people and the buildings and events around the animals shown. You will find a lot more in the animal photographs than you first imagined.

In 2006, the Oregon State Fair was made part of the Oregon State Parks Department. I think the move to that division represents a great opportunity for the fair, for it well understands

historic preservation. I hope that one day soon an on-site museum will be built, a museum that will feature 10,000 images and documents so that people can feel what it was like to attend the fair in years gone by.

Here is a secret about the fair that I will share with you now: there is real gold to be found on the fairgrounds in any given year. In a state known for having two major gold rushes, this is not a statement to be taken lightly. I have seen it many times. And you don't even have to look hard to find it. The gold is not within an exhibit or at the booth of a vendor. The gold of the fair is the young people who attend it: the children who ride the rides and exhibit their animals. I hope they will always be treated by the fair as honored guests. They alone represent the hopes and dreams of the great state of Oregon. As I watch them come to the fair, wide-eyed and excited, I know that among them are future fair directors and maybe even a future fair historian.

You are about to journey where no one has gone before. Many of the photographs in this book were locked away in archives and private collections. Some of them have never been seen and, until now, never seen together. For me, the most exciting photographs were the 1960 presidential campaign photographs of President John Fitzgerald Kennedy. There are also several pictures from the 1800s, the first fairs in Oregon. In still others, we share with early Oregon families the experience of camping in the Oak Grove. The fair was the big event for the year for those families and many stayed a week or more. We even have a photograph of Ben Taylor landing on the racetrack. A stunt unequalled but fondly remembered.

Writing this book and participating in the fair these many years has been an honor I will never forget. I am very grateful for the opportunity. I invite you now to enjoy the Oregon State Fair with me, as we journey across the decades. Let's join Lillie Ward in the Winner's Circle one more time and see if Rufus the bull can plan his great escape. Let's drink a fresh strawberry milk shake as we watch the best from all the counties in Oregon compete. Perhaps nowhere else do Oregonians come together as they do at the Oregon State Fair. And now we can participate in the fair, not just in this year, but a little in each of the 150 or so fairs before.

—Steven Robert Heine

One

THE EARLY YEARS

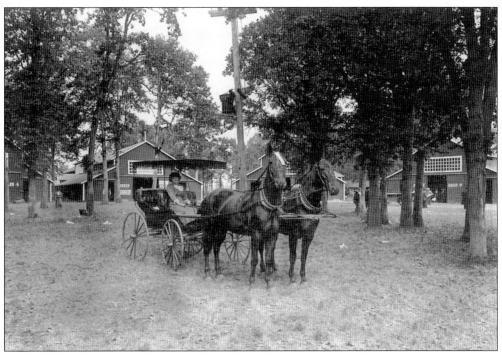

It was the Oregon Agricultural Society and the Oregon Fruit Growers Association that took on the task of creating the first state fair in 1861 held on the banks of the Clackamas River in Oregon City. Times were good in Oregon. Lincoln was president, John Whiteaker was governor, and that little area to the north of the Columbia River had been set free to try to govern itself. Here this image depicts a day at the fair around 1862. In the background, Barns No. 4 and No. 7 and the sheep barn are visible, while several fair visitors look on. (Courtesy of the Oregon State Fair.)

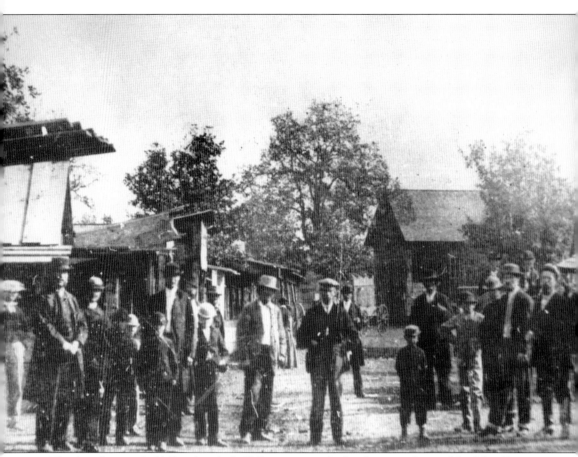

The first fair was held October 1–4, 1861, on a parcel of eight acres donated by John Savage. After a major flood of the Clackamas River, John Minto convinced the state to move the fair to Salem in 1862. In 1863, the fairgrounds expanded with the purchase of 80 acres from David and Margaret Ridout. Another five-and-a-half acres were added in 1865 and, in 1870, 70 more acres would become part of the fairgrounds. In time, the grounds would grow to 185 acres. This photograph depicts fairgoers posing at the second state fair in 1862. (Courtesy of the Oregon State Fair.)

John Minto was born on October 10, 1822, came to Oregon with his family in 1844, and purchased a 250-acre island, now known as Minto-Brown Island, in the Willamette River south of Salem. His primary income came from raising sheep. Minto was only one of several early leaders of the Oregon State Fair. He is important to this book because many of his early documents survive and serve as examples of Oregon life in the 1860s. (Courtesy of the Salem Public Library.)

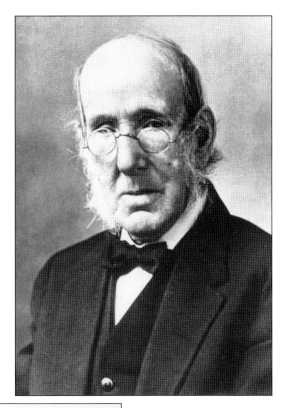

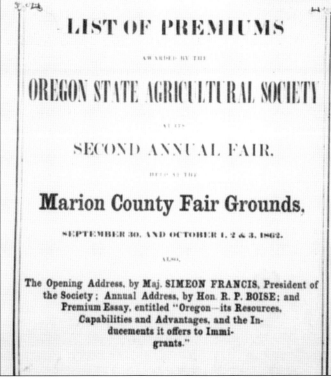

LIST OF PREMIUMS

AWARDED BY THE

OREGON STATE AGRICULTURAL SOCIETY

AT ITS

SECOND ANNUAL FAIR.

HELD AT THE

Marion County Fair Grounds,

SEPTEMBER 30. AND OCTOBER 1, 2 & 3, 1862.

ALSO,

The Opening Address, by Maj. SIMEON FRANCIS, President of the Society; Annual Address, by Hon. R. P. BOISE; and Premium Essay, entitled "Oregon—its Resources, Capabilities and Advantages, and the Inducements it offers to Immigrants."

This is the List of Premiums (the prize list for agricultural and livestock exhibits) for the second Oregon State Fair, held September 30 through October 3, 1862. In 1858, before statehood was even attained, *The Oregon Farmer*, the state's biggest agricultural publication, had begun calling for the establishment of a state fair. With the creation of the Oregon Agricultural Society on September 10, 1860, the foundation for planning this fair was laid. (Courtesy of the Salem Public Library.)

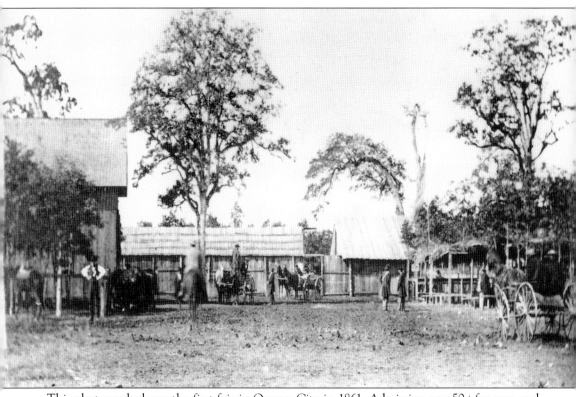

This photograph shows the first fair in Oregon City in 1861. Admission was 50¢ for men and 25¢ for women. It is not surprising that Oregon City was chosen as the site of the first fair; it had been the location of the government for the Oregon Territory. In 1851, the capital was moved to Salem. Statehood came on February 14, 1859. (Courtesy of the Oregon Historical Society.)

This is an early exhibit form reading, "Certificate of Entry, October 1878, Oregon State Board of Agriculture for John Minto." Minto was one of several early leaders and supporters of the Oregon State Fair, and because of him, there is documentation of how things were done at those early fairs. (Courtesy of the Salem Public Library.)

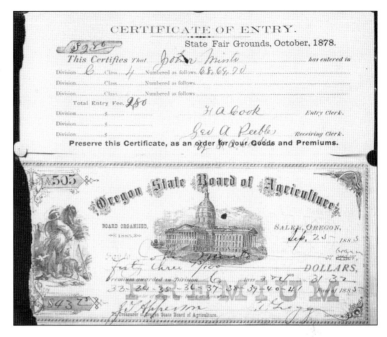

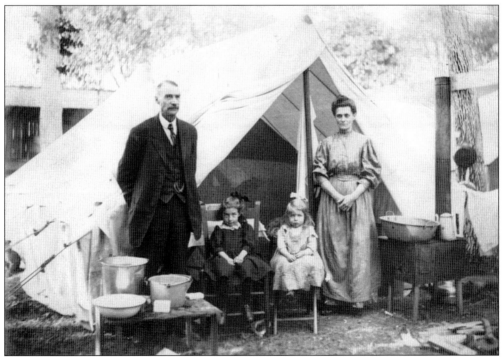

Here is a family of campers at the Oregon State Fair around 1870. For generations, camping at the fair was the highlight of the year for many Oregon families. They traveled by wagon or train, and it sometimes took several days just to reach the fairgrounds. This was a rare chance to interact with people from all over the state and to be part of a unique event and the temporary communities within the fair. (Courtesy of the Oregon State Library.)

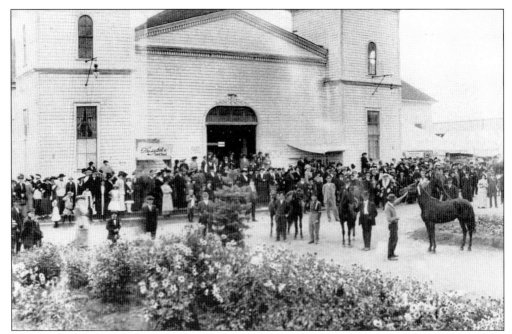

These folks visit the first Oregon State Fair in Oregon City in 1861. Space was an early problem as well as flooding of the Clackamas River. There was also a need to move the fair closer to the agricultural community. Visible in the background is the Busy Bee Lunch Stand. (Courtesy of the Marion County Historical Society.)

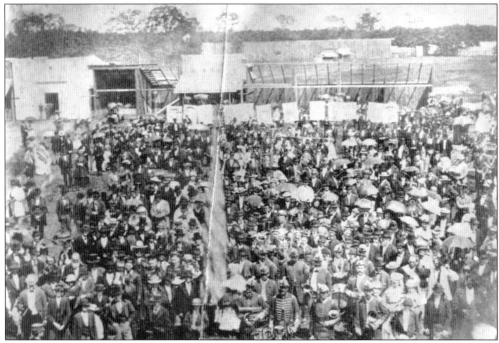

This is one of the few photographs from the 1861 Oregon City Fair. The next year, the fair moved to Salem in order to be closer to the state's biggest industries—agriculture, livestock, and timber. (Courtesy of the Marion County Historical Society.)

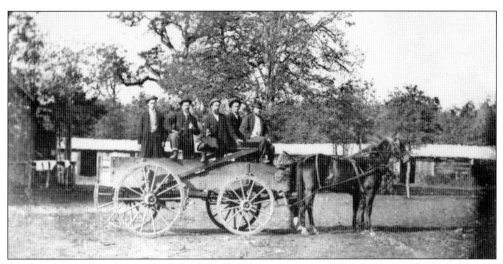

In 1862, men pose on a wagon at the first Oregon State Fair in Salem. If the fair had left Oregon City to escape floods, then the problem was only partially solved. The area chosen in North Salem was one of the lowest spots, and residents on nearby streets would battle standing water for decades to come, some finding six inches of water in their garages each winter. The fair itself would struggle to remove the water of heavy Oregon rains that often considered themselves invited fair guests. The 1st Oregon Volunteer Infantry, which organized in 1864–1865, also used the fairgrounds, as barracks, and four companies of the infantry were mustered at a place called Camp Russell, which was in fact at the Oregon State Fair. (Courtesy of the Oregon State Fair.)

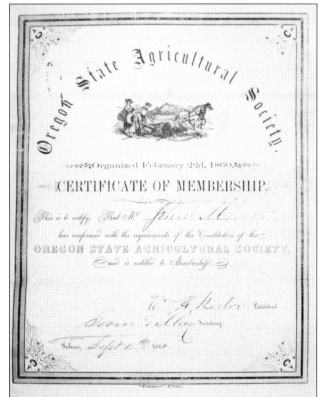

This certificate of membership reads as follows: "Oregon State Agricultural Society, organized February 22d 1860. . . . This is to certify that John Minto has conformed to the requirements of the constitution of the Oregon Agricultural Society and is entitled to membership. Sept. 11, 1860." (Courtesy of the Salem Public Library.)

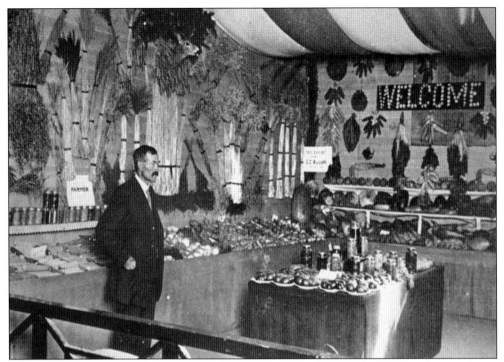

In the 1860s, a farmer presents the best of his harvest at a display, which required a lot of time and work to create. Clearly, despite the demands of harvest, the man felt it was important to be at the fair. Although the United States was in the middle of the Civil War, Oregon was continuing to grow and prosper while struggling to find its place among the states. (Courtesy of the Oregon State Fair.)

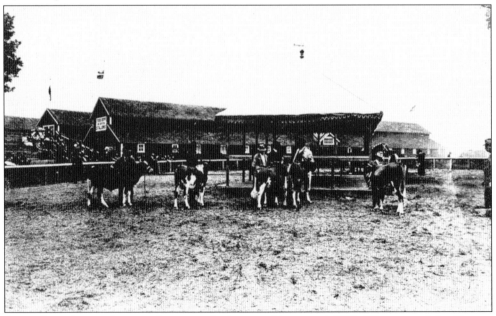

An early tradition, these cattle are on display at a fair around 1870. (Courtesy of the Oregon State Library.)

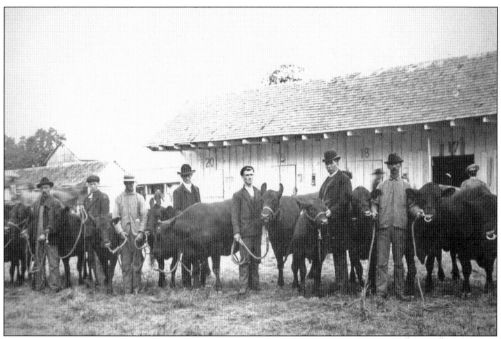

Competitors and animals meet at the fair in 1864. (Courtesy of the Oregon State Fair.)

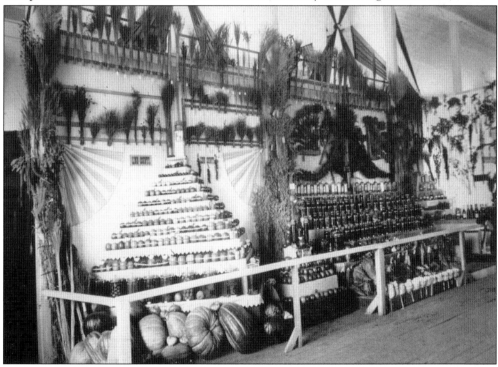

The Linn County display, one of the best early exhibits, is pictured here around 1870. By 1895, the duration of the fair was increased to 10 days, and Oregon Agricultural College (which would later become Oregon State University) was invited to help in the planning of exhibits. Even bicycle races were added to the list of events. (Courtesy of the Oregon State Library.)

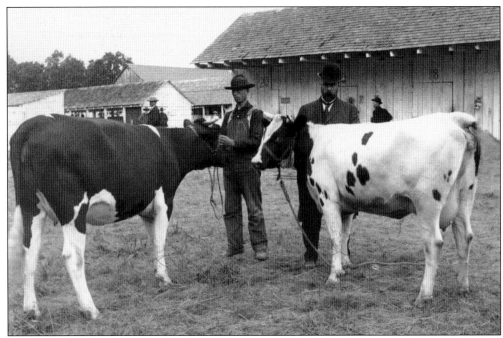

Getting a cow to smile for the camera was not easy, even in the 1870s. In these photographs, competitors prepare animals for judging around 1870. Early buildings were small and did not meet the needs of a growing fair for very long. (Both courtesy of the Oregon State Library.)

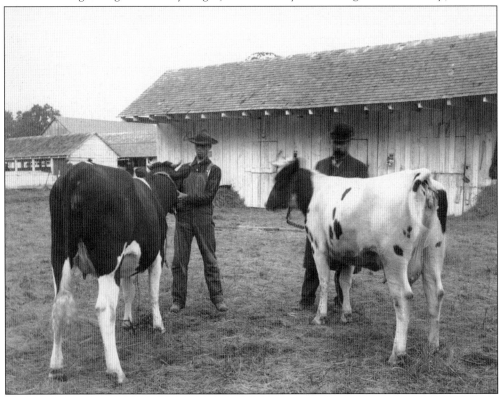

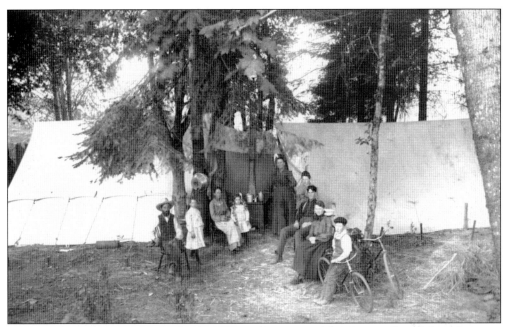

Early campers take time to pose for the camera. (Courtesy of the Oregon State Library.)

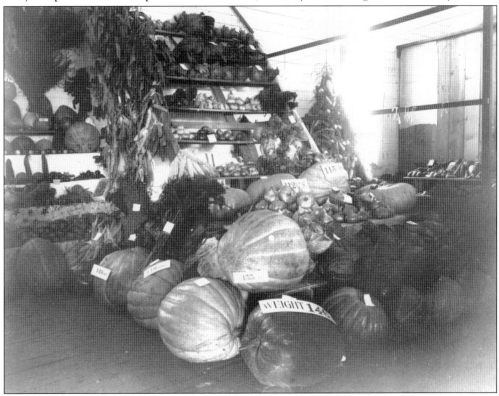

Winning pumpkins, at 155 and 146 pounds each, might seem small in 2007, but in the late 1800s, they were gigantic. As with most things, the best in the state came to the fair to compete. (Courtesy of the Oregon State Library.)

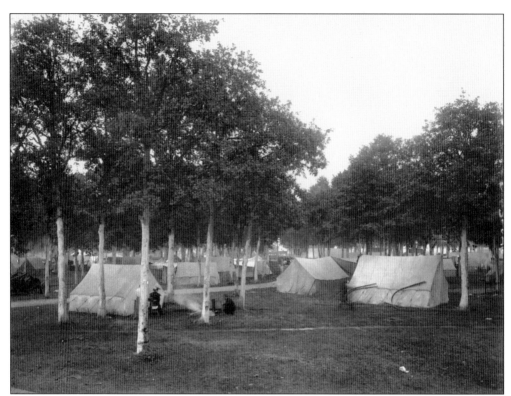

Around 1870, a man builds a fire, while two women prepare a meal near the tents in Oak Grove. Photographs of camping at the fair are among the most treasured. (Courtesy of the Oregon Historical Society.)

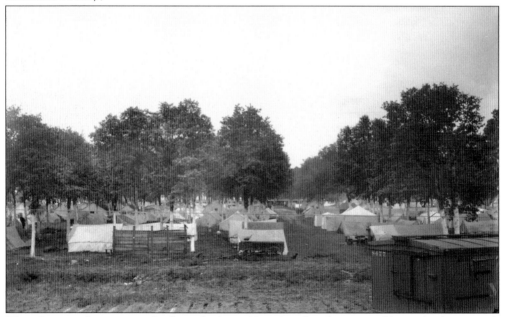

This photograph appears to be from the late 1870s. A railroad car is visible in the foreground. (Courtesy of the Oregon Historical Society.)

Two

1900–1939

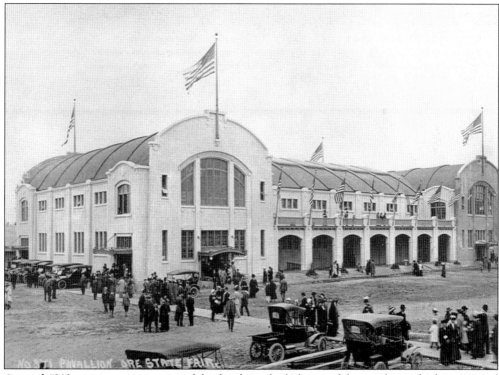

Around 1910, visitors enjoy a view of the fair from the balcony of the pavilion, which is pictured later in this book looking dramatically different. Note the wooden sidewalks. (Courtesy of the Oregon State Library.)

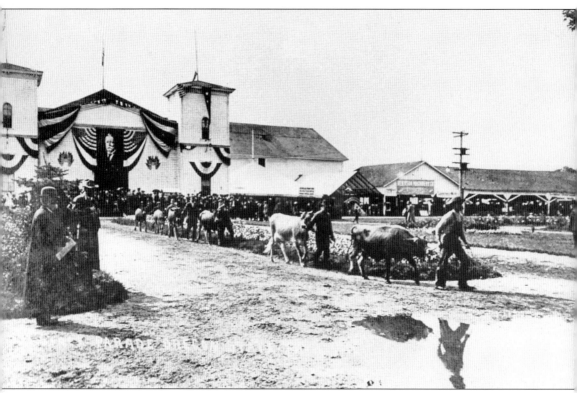

This is the Stock Parade at the fair in 1907. Heavy rains turned much of the fairgrounds to mud. (There was some question about the year the image was taken. The photograph on the building is reportedly of William Taft, who served as president from 1909 to 1913. Teddy Roosevelt was president in 1907.) (Courtesy of the Salem Public Library.)

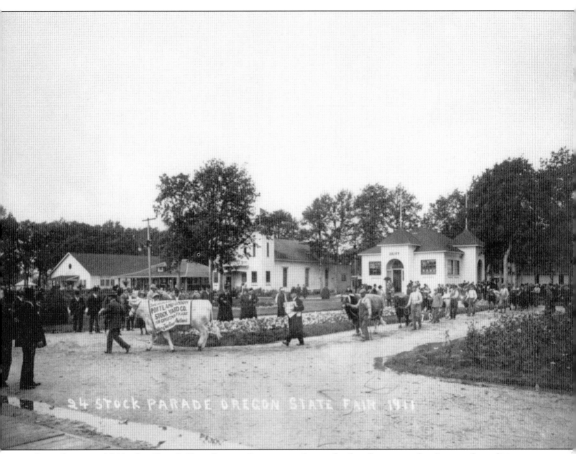

Seen here in 1911, the Stock Parade winds its way through the fairgrounds. A grand tradition, the parade was an event of many early fairs. As the fairs became larger and hundreds of animals were added, the event clearly was not feasible. Note the wonderful old buildings in background. (Courtesy of the Salem Public Library.)

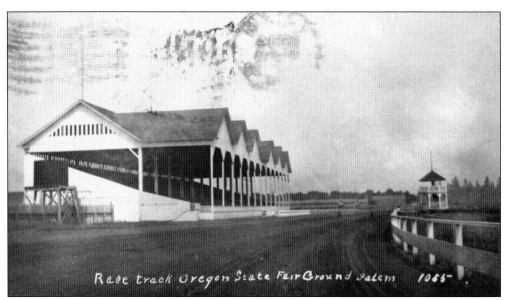

Here is how the racetrack at the fairgrounds looked in 1908 with a judge's stand to the right. (Courtesy of the Salem Public Library.)

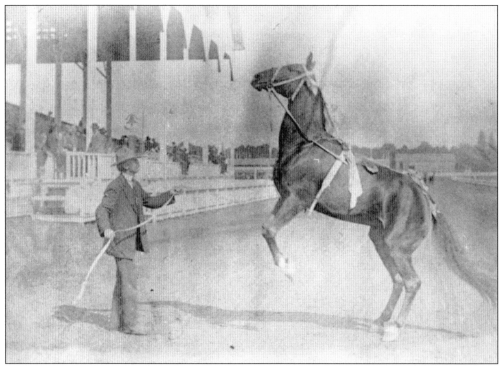

A man holds a rearing horse in front of the grandstand in 1915. (Courtesy of the Marion County Historical Society.)

A team of draft horses is pictured here around 1910. Thousands of amazing animals have come through the fair during its 146-year history, and they definitely bring their personalities and their energy. (Courtesy of the Oregon State Library.)

Draft horses are on parade around 1915. Note the steering wheel on the right side of the Buick to the left. (Courtesy of the Oregon State Library.)

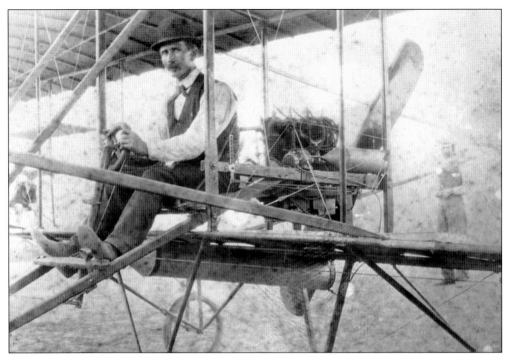

Ben Taylor lands his airplane on the racetrack in 1910. It is not certain if Ben was trying to impress fairgoers with his flying skills or just trying to get out of paying admission. (Courtesy of the Salem Public Library.)

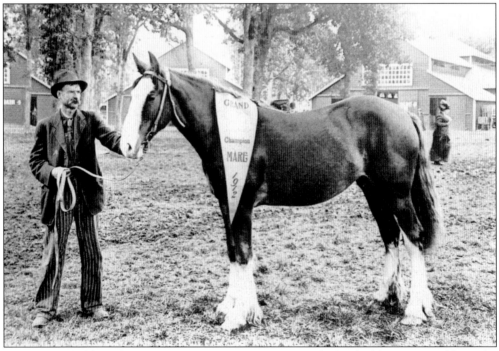

This man is holding the grand champion mare in 1912. Early fair buildings are visible in the background. (Courtesy of the Oregon State Library.)

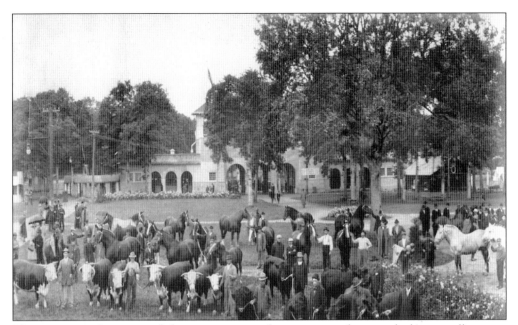

The images on this page and the next are part of a panoramic photograph that actually covers about 200 feet. This one represents the far left of the panorama. Fair visitors seem to be strolling through large main gates in the background into the fairgrounds, while cattle are on display in the foreground. (Courtesy of the Oregon State Fair.)

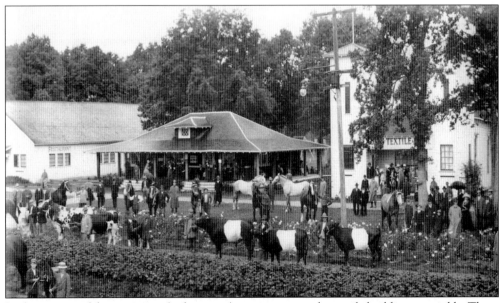

In this section of the panorama (right center), a restaurant and a textile building are visible. These do more than any other group of images to show the layout of the early fairgrounds. (Courtesy of the Oregon State Fair.)

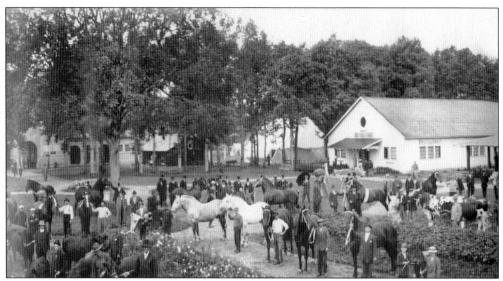

In this section (left center), the photographer seems to have the complete attention of hundreds of people and dozens of animals. The image was obviously taken from a high platform on the fairgrounds. (Courtesy of the Oregon State Fair.)

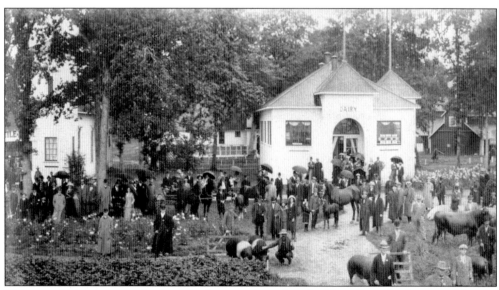

This part of the panorama, the far right, features a large dairy building. Does the fair groundskeeper know that the hogs in the foreground are snacking on the landscape plants? The fair is full of delicious treats to satisfy everyone's taste. (Courtesy of the Oregon State Fair.)

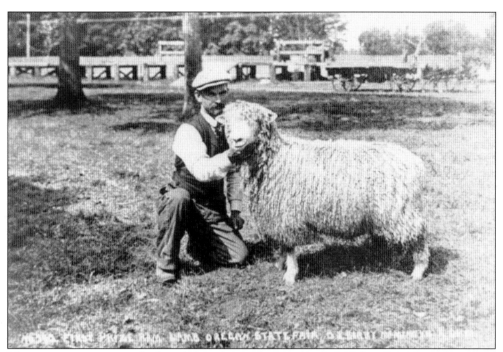

This prize-winning ram, which took first place, was owned by D. J. Kirby of McMinnville around 1910. (Courtesy of the Marion County Historical Society.)

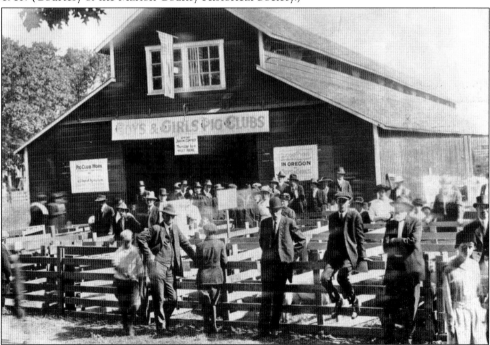

This is the Boys and Girls Pig Club exhibit at the 1917 fair. Many of these young people dedicated their lives to Oregon agriculture. The fair was an important tool for promoting the parts of the agricultural community that were important to the state's economy. It also taught young people how to be successful within that community. (Courtesy of Oregon State University.)

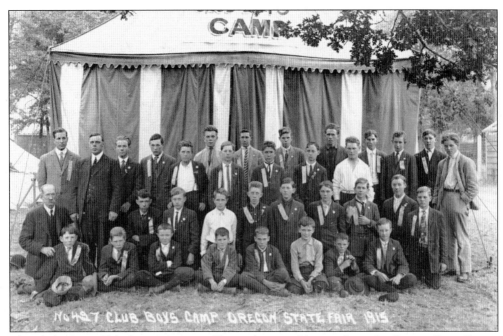

This is the Boys Club Camp, a group of boys who raised livestock, at the Oregon State Fair in 1915. (Courtesy of Oregon State University.)

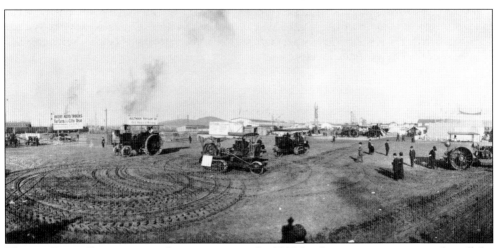

This is a Caterpillar equipment demonstration at the 1915 fair. It is interesting to note that all the men in the photograph are wearing top hats and suits. (Courtesy of the Salem Public Library.)

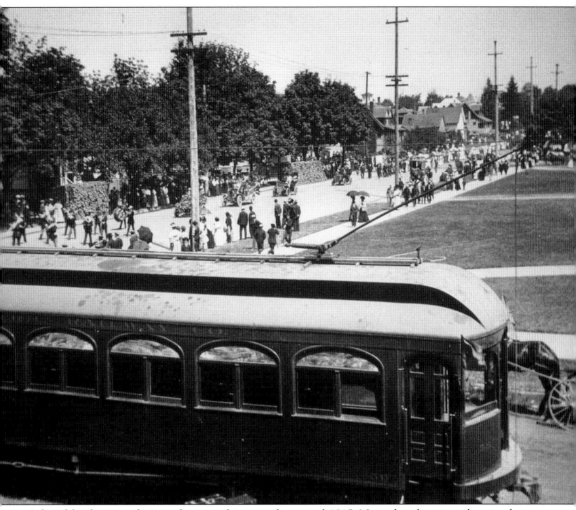

A band leads a parade into the state fairgrounds around 1915. Note the electric railcar in the foreground. The fair is fortunate to have railroad access. Trains are able to drive right into the fairgrounds, a fact that was perhaps even more critical at the earlier fairs before the automobile. (Courtesy of the Oregon State Library.)

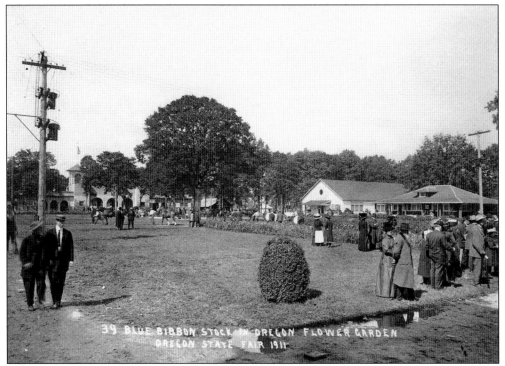

Here in 1911, visitors enjoy the flower gardens, for which the fair has always been famous. Some fairgoers still come just for the gardens. (Courtesy of the Oregon State Library.)

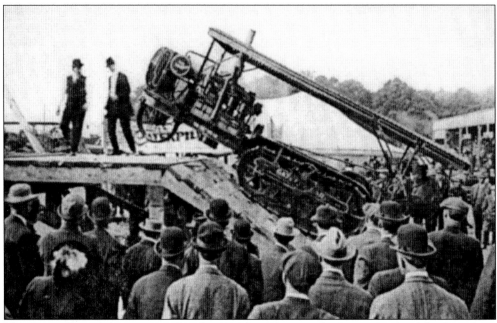

The Caterpillar exhibit is pictured at the 1915 fair. This was the "serious" side of the fair, where the state's industries showcased various innovations. (Courtesy of the Salem Public Library.)

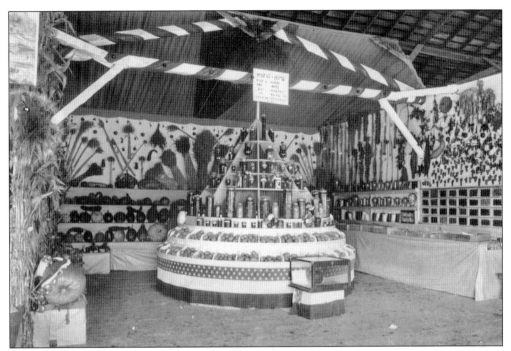

Around 1910, a sign at this county display reads, "Wheat is King." Note the Studebaker wagons and bumper sticker to the right of the display. (Courtesy of the Oregon State Library.)

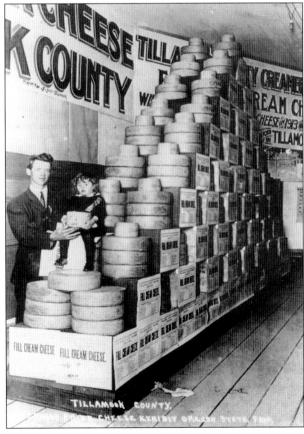

In 1913, an adorable girl sits on a mountain of the best cheese in the state—the first place cheese exhibit by Tillamook County. (Courtesy of the Oregon Historical Society.)

Here is the old gate at the entrance to the fairgrounds in 1911. It was a landmark of the early fairs and was the first thing visitors saw upon arriving. This old gate may have been where the fair offices currently are. (Courtesy of the Marion County Historical Society.)

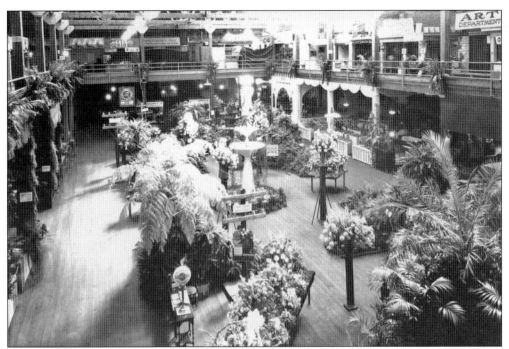

This is another view of the flower display inside the fair around 1920. The restaurant in the background offers ice cream sandwiches for 10¢. (Courtesy of the Oregon State Library.)

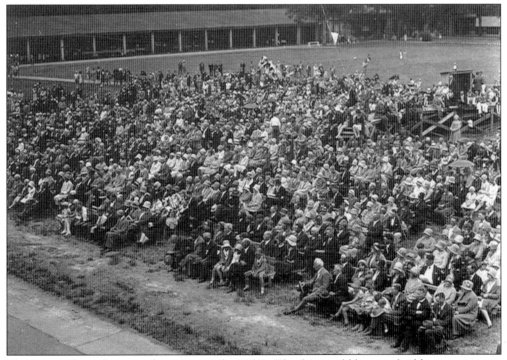

Here a crowd watches a performance in the 1920s. The fair would have to build entertainment facilities to meet the needs of audiences. Unfortunately, it is not known what the platform in the far right background was used for. (Courtesy of the Oregon State Library.)

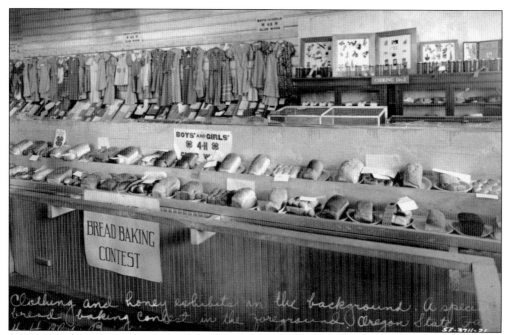

Pictured is the 4-H baking contest and clothing exhibit in 1921. The 4-H has long been an important part of the fair. There are many other Oregon organizations that would do well to follow the lead of the 4-H and establish their own traditions at the fair. (Courtesy of Oregon State University.)

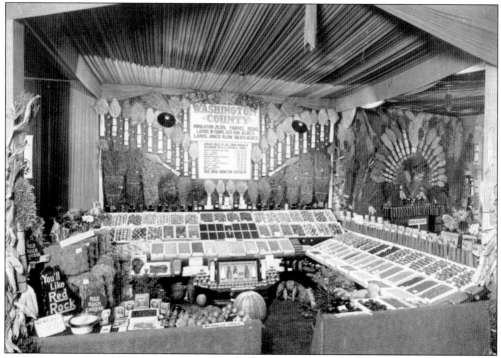

Pictured here is the Washington County produce exhibit at the 1925 fair. Note the attention to detail and time put into this exhibit. (Courtesy of Oregon State University.)

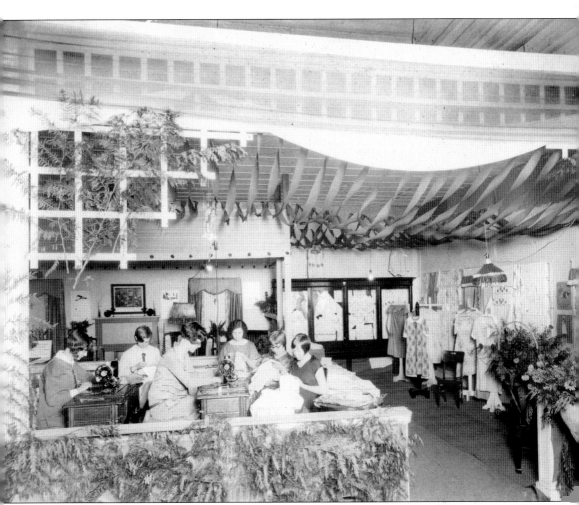

Students from Oregon School for the Deaf work on fabrics at a state fair exhibit in 1927. The fair has been a great place to showcase the talents and achievements of generations of Oregon's young people. (Courtesy of the Oregon State Archives.)

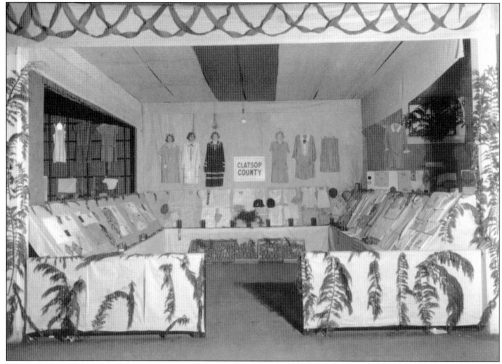

This is the Clatsop County Boys and Girls Club exhibit at the 1927 fair. (Courtesy of Oregon State University.)

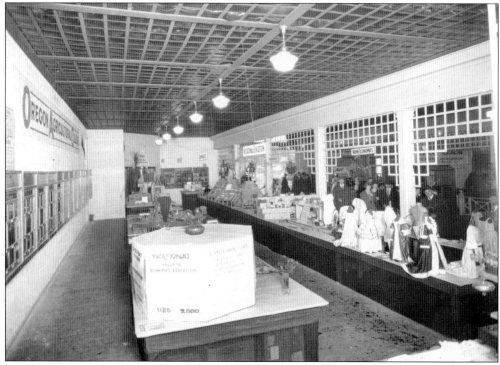

This was the Oregon Agricultural College exhibit in 1927. (Courtesy of Oregon State University.)

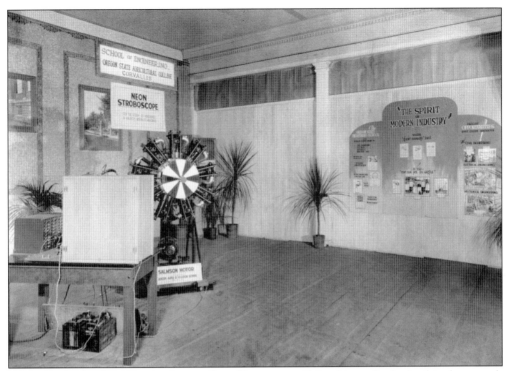

A new motor developed by the Oregon State Engineering School is on display in this photograph by Wanda Gifford. (Courtesy of Oregon State University, the Wanda M. Gifford Collection.)

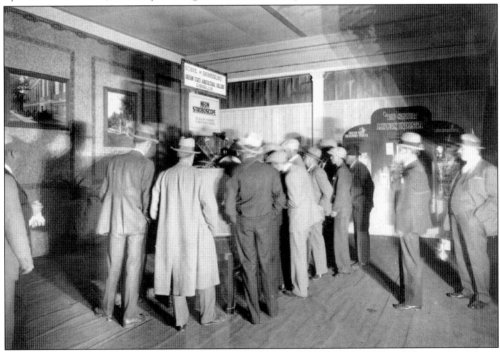

In this second shot of the exhibit, the photographer shows (in a slight time lapse) the crowd rushing to see the new innovation at the 1931 Oregon State Fair. (Courtesy of Oregon State University.)

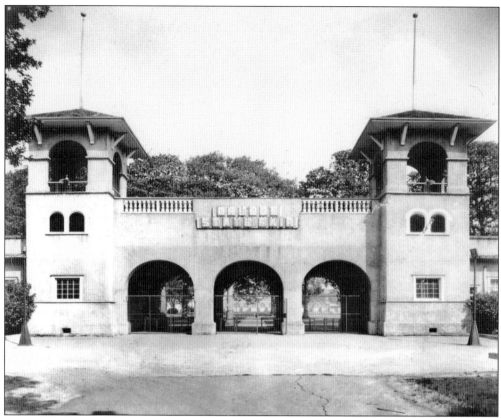

This is the main gate to the fairgrounds in 1933. The sign at the top of the gate reads, of course, Oregon State Fair. This entrance is of considerable interest, and no one is sure when it was torn down. It appears this gate was near where fair offices are located now. (Courtesy of the Oregon Historical Society.)

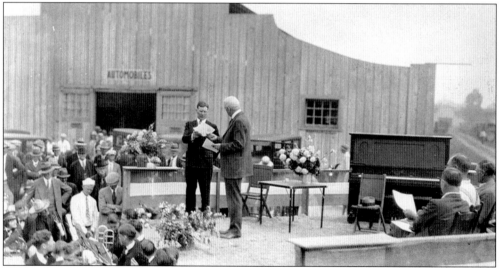

A music competition has just taken place sometime during the 1930s. The competitor on the left received an award following the performance. (Courtesy of the Oregon State Library.)

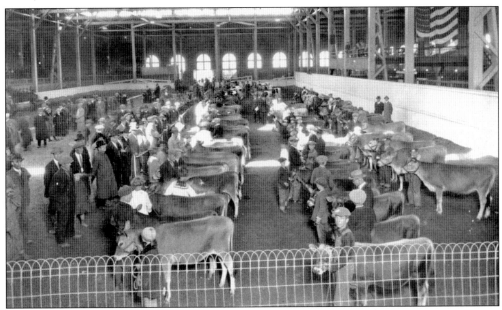

During the 1930s, cows are being judged at the fair. This may be one of the few remaining images of the old pavilion. (Courtesy of Oregon State University.)

SEVENTY-FOURTH

Oregon State Fair

August 31 to September 7, 1935

A0000111051959

Future Farmers of America
AND
Smith-Hughes Agricultural

PREMIUM LIST

1935

STATE DEPARTMENT OF AGRICULTURE
AND
STATE BOARD FOR VOCATIONAL EDUCATION
Cooperating

S. T. White, *Director*, Oregon State Fair

O. D. Adams, State Director for Vocational Education
Earl R. Cooley, State Supervisor of Agricultural Education

S. T. WHITE, *Director*

MAC HOKE, *Chairman*, Pendleton	Animal Industry
J. O. HOLT, Eugene	Horticulture
GEO. FULLENWEIDER, Carlton	Dairying
FRED COCKELL, Milwaukie	Poultry
G. A. BROWN, Portland	Cooperative Marketing
E. A. GEARY, Klamath Falls	Farm Crops
FRANK ROWELL, Scholls	Vegetable Crops

OREGON STATE BOARD FOR VOCATIONAL EDUCATION

Ex officio:

Governor CHARLES H. MARTIN	Salem
Secretary of State EARL SNELL	Salem
State Superintendent C. A. HOWARD	Salem
E. W. McMINDES (representing agriculture)	Astoria
Mrs. MARY E. JONES (representing homemaking)	Freewater
H. R. KREITZER (representing employers)	Portland
EDWARD J. STACK (representing labor)	Portland

STAFF

O. D. ADAMS	State Director
EARL R. COOLEY	State Supervisor of Agricultural Education
BERTHA KOHLHAGEN	State Supervisor of Home Economics Education
O. I. PAULSON	State Supervisor of Rehabilitation
O. D. ADAMS	State Supervisor of Trade and Industrial Education

TEACHERS OF VOCATIONAL AGRICULTURE IN OREGON
1935-1936

ALBANY—Jens F. Svinth	IMBLER—Joe Jarvis
AMITY—E. E. Jackson	INDEPENDENCE—Howard Bennett
ARLINGTON—Wm. Bennett	LEBANON—Geo. Blinkhorn
BANDON—Morris Buchanan	McMINNVILLE—Eston Ahlstrom
BOARDMAN—Roy Murry	MALIN—A. E. Street
BONANZA—Wm. Holloway	MOLALLA—E. E. Rowland
CANBY—Chas. Taggart	MYRTLE POINT—Roland Schaad
CLOVERDALE—Ira Forrey	NEWBERG—W. C. Leth
CONDON—V. C. Hill	ONTARIO—O. D. Dearborn
COOS RIVER—To be selected	OREGON CITY—Howard Gibson
COQUILLE—Floyd McDonald	PENDLETON—Geo. W. Dewey
CORVALLIS—O. K. Beals	RAINIER—Robert Dietrick
COTTAGE GROVE—Elmer Berg	REDMOND—B. F. Beck
CRANE—Homer Oft	ROSEBURG—Homer Grow
DUFUR—A. C. McLean	SALEM—Ralph Morgan
ENTERPRISE—Edw. Axtell	SCAPPOOSE—Wm. Kessi
FOREST GROVE—R. M. Adams	SILVERTON—W. E. Crabtree
GRANTS PASS—W. S. Carpenter	THE DALLES—Chas. Reiter
GRESHAM—Kirby Brumfield	UNION—Harold Finegan
HALFWAY—Robert Harper	WALLOWA—To be selected
HENLEY—A. W. Cole	WOODBURN—J. S. Johnson

Here is the premium list for 1935. Charles Martin was governor, and S. T. White was the fair director. One year earlier, in 1934, a 1 1/3-mile racetrack was built for the fair. Also in 1934, a wagon train left Boston to mark the centennial of Jason Lee's arrival in Salem. Lee is one of the founders of Salem and also was a founder of Willamette University. (Courtesy of the Oregon State Library.)

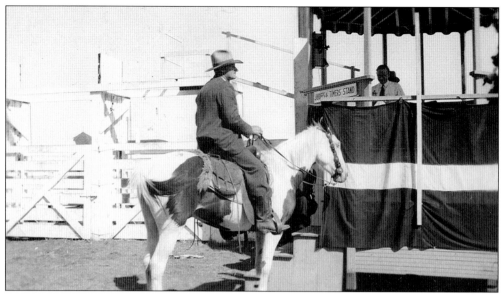

A rider checks in at the judge's stand at the racetrack in the 1930s. A "seeing eye" was added to the racetrack in 1939 to accommodate photo finishes. (Courtesy of the Oregon State Library.)

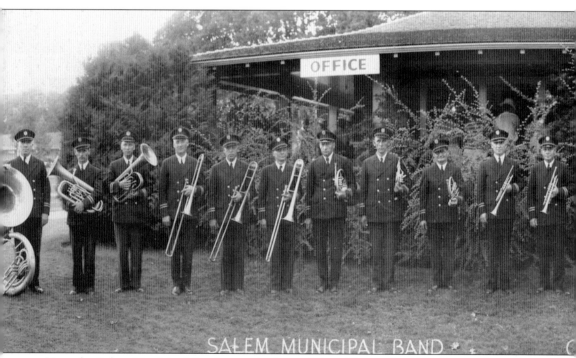

Here the Salem Municipal Band poses in front of the office at the 1935 Oregon State Fair.

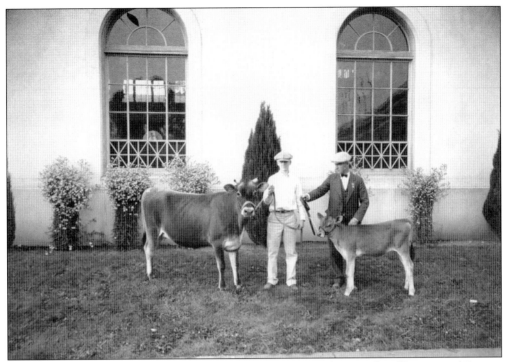

A young man holds a calf and young bull ready for judging at the 1936 fair. (Courtesy of Oregon State University.)

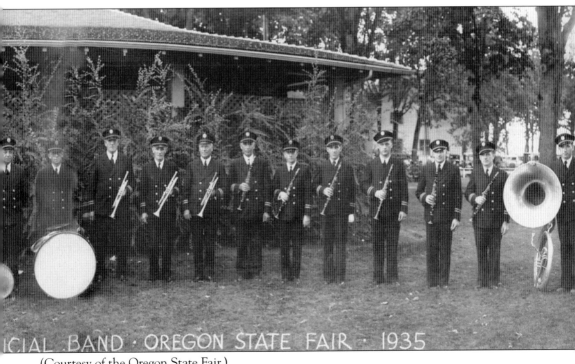

ICIAL BAND · OREGON STATE FAIR · 1935

(Courtesy of the Oregon State Fair.)

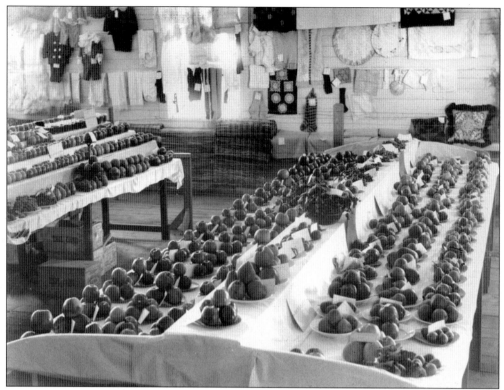

A county display around 1930 offers hungry fairgoers a view of ripe fruit in beautiful displays but posts several signs that read "Hands Off!" (Courtesy of the Oregon State Library.)

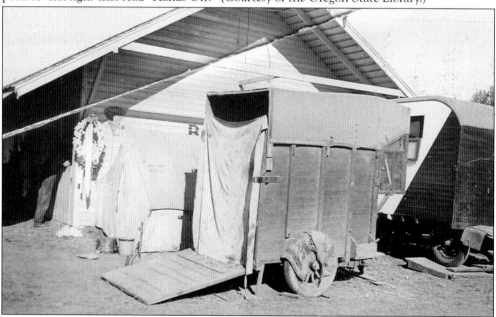

This horse trailer is parked beside a cabin at a *c.* 1930 fair. The owner is just out of sight, but the flowers indicate that the horse has clearly won a recent race. Note the wheel covers. (Courtesy of the Oregon State Library.)

The Oregon State Fair seemed a formal event in the 1930s, as all these visitors are well dressed. In 1933, admission was reduced from 50¢ to 25¢ per adults. In 1934, a caravan reenacted the 100th anniversary of the arrival of Jason Lee, the town's founder, in Salem. The old pavilion is visible in the background. (Courtesy of the Oregon State Fair.)

In this 1930s photograph, two farmers give serious consideration to what may have been an early combine machine, which would allow them to double production. The fair has always provided farmers with displays of the newest developments in agricultural machinery. Much of this equipment still survives in museums like Antique Powerland in Brooks. (Courtesy of the Salem Library.)

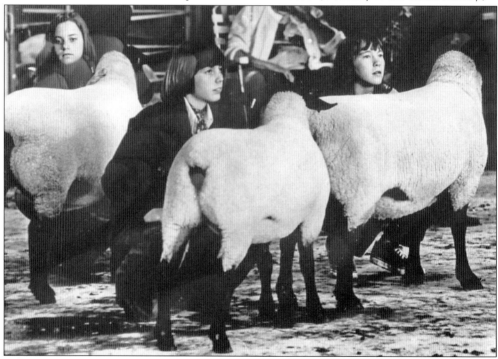

Three 4-H girls wait for their sheep to be judged at the 1931 fair. This is a big part of what the fair is about—a young person, a spirited animal, and months of hard work about to come down to a few moments before a judge. (Courtesy of the Marion County Historical Society.)

Three

THE 1940S AND 1950S

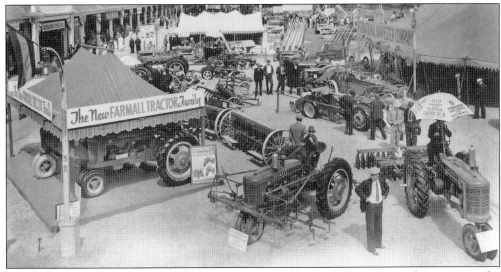

This is the International Harvester Exhibit in 1940. Note the boy trying out the tractor in the center of the photograph. (Courtesy of the Oregon Historical Society.)

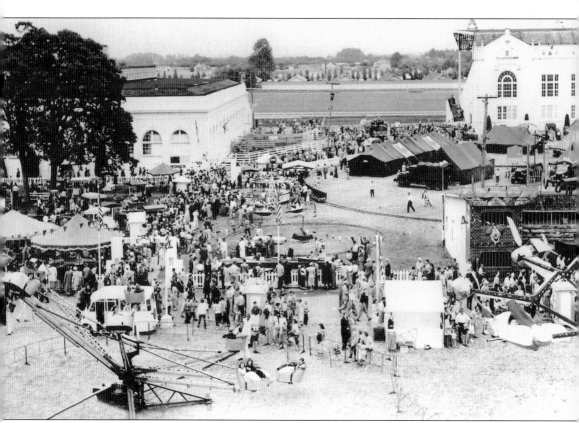

This 1949 photograph of the midway shows Kiddie Land, with rides, a fun house, and mini-trains. Fairgoers just politely step over the train tracks that seem to be all over the fairgrounds. Most early amusement rides either spun around in the air or moved across some type of fixed track. (Courtesy of the Oregon Historical Society.)

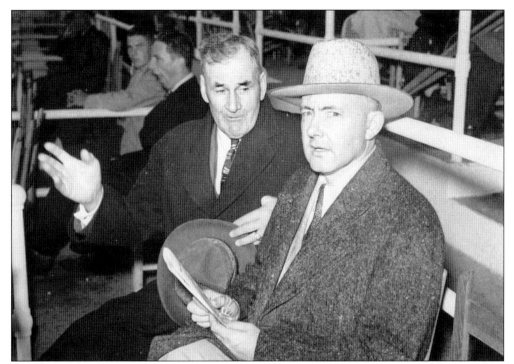

Oregon governor Charles Sprague and Oregon Department of Agriculture secretary J. D. Mickle are pictured here at the 1940 fair. Governor Sprague, elected in 1939, served one term. (Courtesy of the Salem Public Library.)

Fair director Leo Spitzbart is ready to welcome guests to the 1947 Oregon State Fair. After the fair closures during the war years, it was important to let the public know the fair was open for business. Gov. Earl Snell also helped by broadcasting the opening ceremonies on the first day of the fair. (Courtesy of the Oregon Historical Society.)

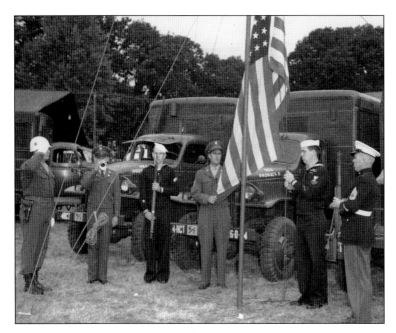

This salute to America, to victory, and to the fair took place on the first day of the 1949 fair. (Courtesy of Oregon State Archives.)

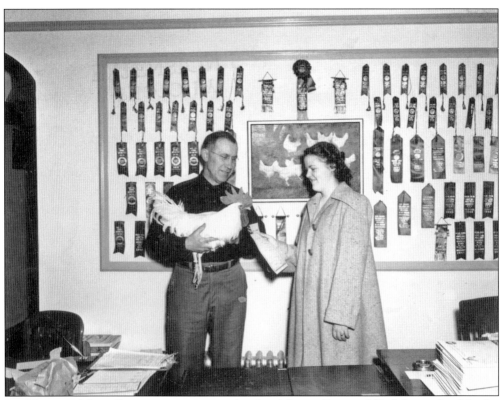

Jess Hansen of Corvallis presents a prize cockerel to Marion County 4-H club member Martha Harper of Brooks at the 1948 fair. (Courtesy of Oregon State University.)

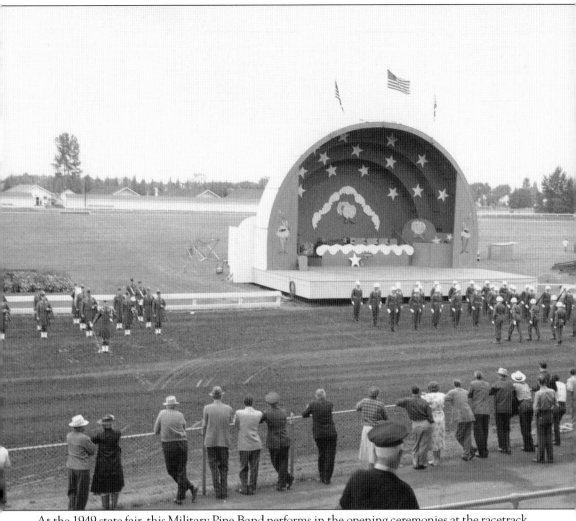

At the 1949 state fair, this Military Pipe Band performs in the opening ceremonies at the racetrack. (Courtesy of the Oregon State Archives.)

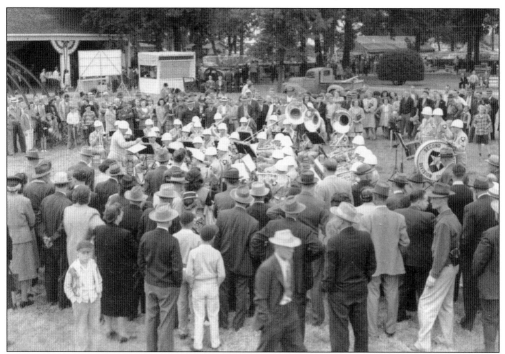

In 1942, the fair was scaled back to include only 4-H displays, livestock exhibits, and county displays. The fair was then suspended during the latter part of World War II in 1943 and 1944. Here a crowd enjoys a military band at the fair in 1946. (Courtesy of the Salem Public Library.)

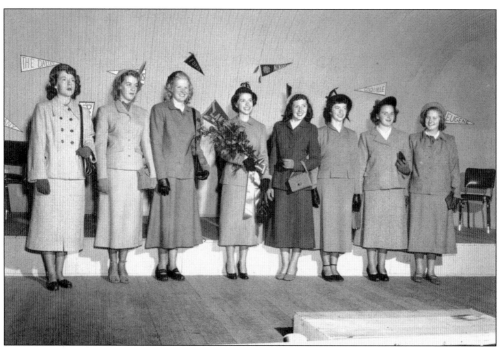

Blue- and red-ribbon winners, all in wool suits, are members of the class of 1949 4-H Club Style Review. (Courtesy of Oregon State University.)

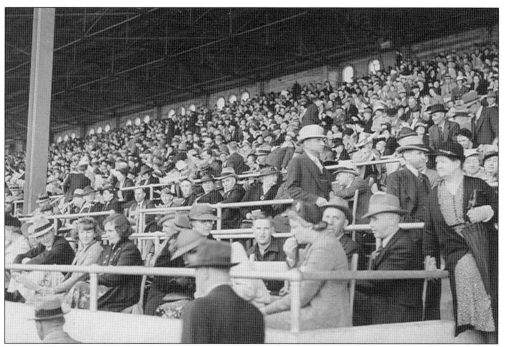

This view is of a crowd at the racetrack in the 1940s. For more than 100 years, horse racing provided entertainment at the fair. (Courtesy of the Oregon State Library.)

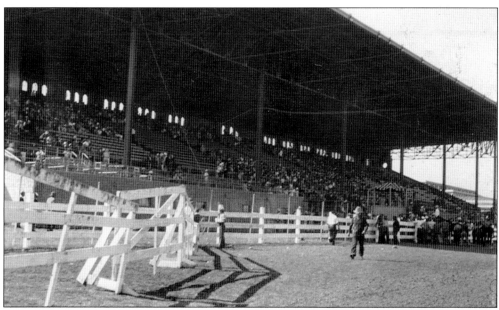

Here is the grandstand about 1940. Pari-mutuel betting was introduced to the fair in 1933. (Courtesy of the Oregon State Library.)

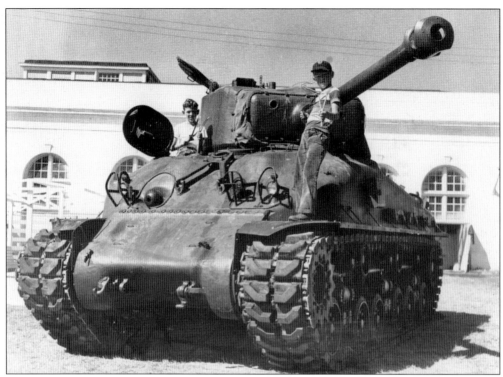

At the 1949 fair, two boys with slingshots stand guard over a tank, which may have seen duty in World War II, at a military display. At the moment, the boys and their slingshots pose a greater danger than the tank itself. (Courtesy of the Oregon State Archives.)

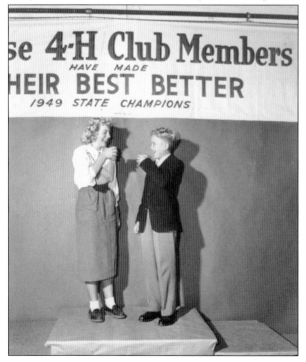

Barbara Brown, 14, of Corvallis and Harold Brost, 11, of Portland were named "Health Champions" at the 1949 fair. (Courtesy of Oregon State University.)

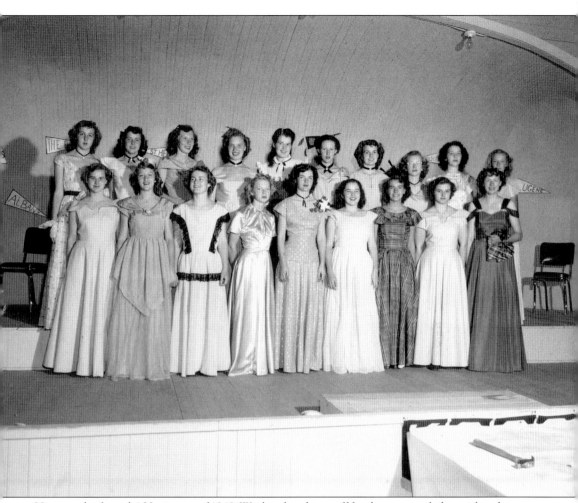

Here are the formal 4-H winners of 1949. Weeks of work pay off for these young ladies with a chance for a ribbon and a small place in the history of the fair. (Courtesy of Oregon State University.)

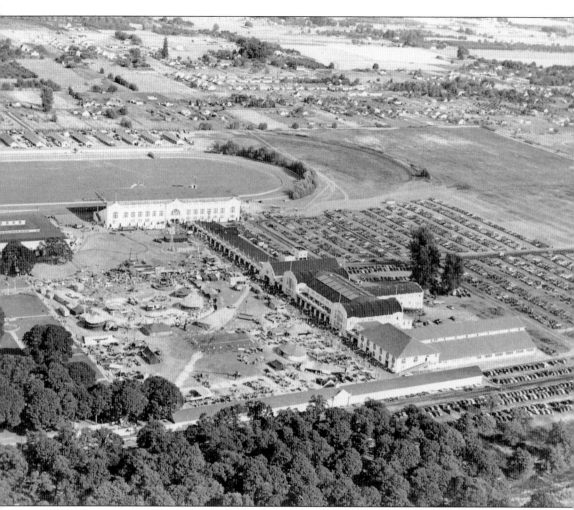

This 1940s view of the fairgrounds shows most of the early structures on the eve of change. Note that the buildings seem to be in about the middle of the current fairgrounds. There is some evidence that the racetrack had been much larger in earlier years. (Courtesy of the Salem Public Library.)

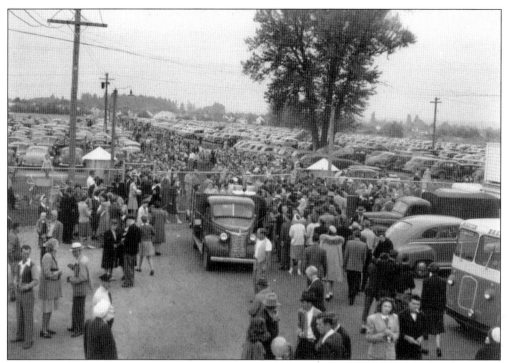

This photograph shows the crowds at the fair in 1946. Following a two-year complete closure during World War II in 1943 and 1944 (1942 had a scaled-back event with only livestock exhibits and 27 displays), Oregonians were glad to get their state fair back. (Courtesy of the Salem Public Library.)

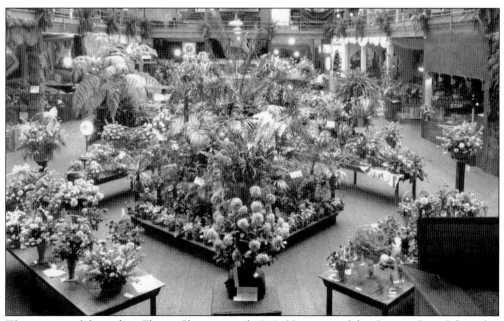

This view is of the indoor Flower Show around 1940. (Courtesy of the Oregon State Library.)

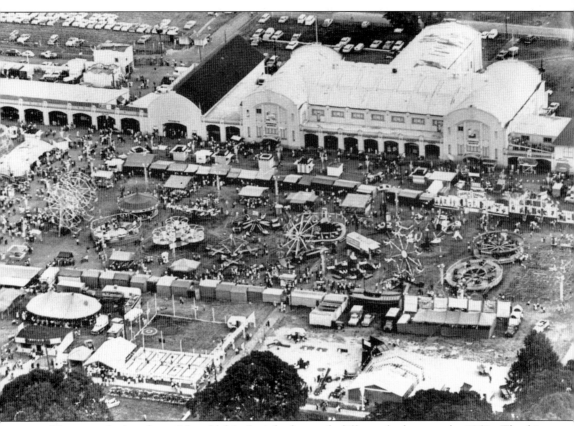

These are the last days of the old fair, for it had a much different look come the 1950s. The fair would have to dramatically change to accommodate the growing crowds and the changing needs of the state. (Courtesy of the Oregon State Fair.)

Romance is in the air in this nighttime view of the 1949 fair. (Courtesy of Oregon State University, Wanda Gifford Collection.)

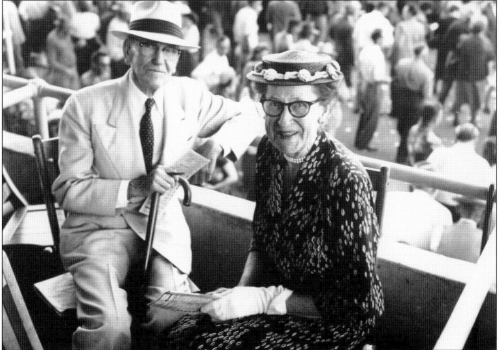

Former governor Oswald West and his wife, Mabel, enjoy the 1953 fair. Governor West, elected in 1911, served only one term. (Courtesy of the Salem Public Library.)

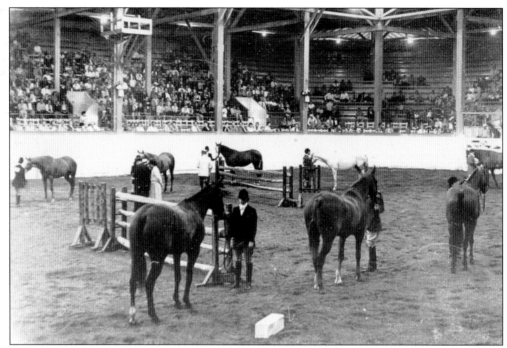

This interior photograph of the Horse Pavilion shows the grandstand and arena in 1955. (Courtesy of the Marion County Historical Society.)

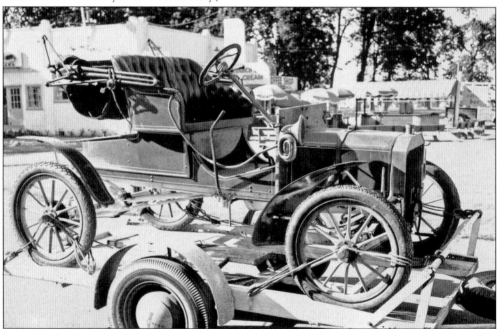

Because of the time it took to travel to Salem, the early fairs were held more for the counties of the mid-valley. It was not until the invention of the automobile that it truly became a "state fair." Families could now travel from all over Oregon to be a part of it. These antique automobiles, on exhibit at the 1953 fair, played a critical role in changing the fair. (Photograph by Ben Maxwell; courtesy of the Salem Public Library.)

A man closely examines an antique automobile at the 1953 fair. It is really the incidental images of the fair that are the most interesting—those tiny moments caught on film. (Photograph by Ben Maxwell; courtesy of the Salem Public Library.)

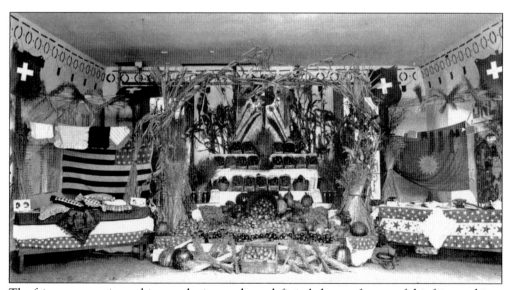

The fair goes on, rain or shine, and rain may have definitely been a feature of this fair; stockings and books dry on a line running through the booth. This 1950s county display features quilts and produce. (Courtesy of the Oregon State Library.)

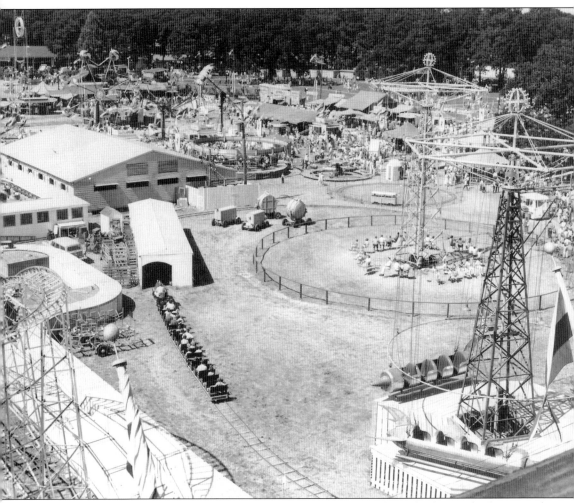

This 1956 view of the midway shows the development of many rides at the fair. In the foreground, passengers ride a small train, which traveled through one building and on around the grounds. The famed giant roller coaster is on the left, fairgoers prepare to ride a giant swing in the center, and three rocket ships are on the right. (Courtesy of the Oregon Historical Society.)

Why do men really go to the fair? Perhaps it is to see all the marvelous machines from days gone by, like this antique automobile display in 1953. In 1951, the legislature moved the fair from the possession of the Oregon Department of Agriculture and placed it under the jurisdiction of a new organization—the State Fair Commission. Each member of the commission would be appointed by the governor and serve a four-year term. (Courtesy of the Salem Public Library.)

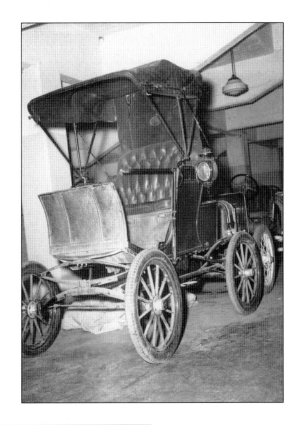

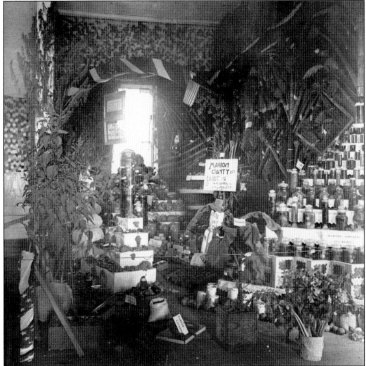

This is the Marion County exhibit created by W. A. Jones and C. M. LaFollett. The *c.* 1950 display features, among other things, English cucumbers and tobacco. (Courtesy of the Oregon State Library.)

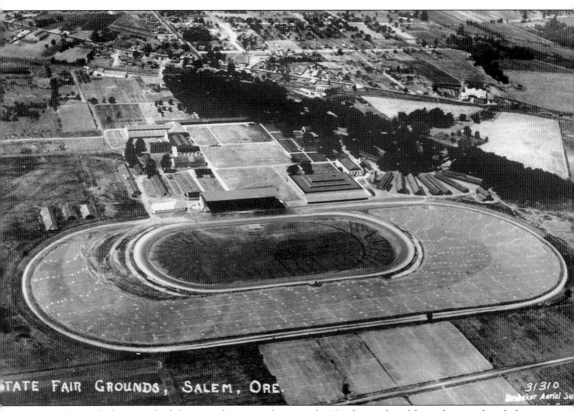

TATE FAIR GROUNDS, SALEM, ORE.

31310
Brubaker Aerial Su

This Brubaker aerial of the state fairgrounds around 1950 shows the old pavilion and early barns. (Courtesy of the Oregon State Library.)

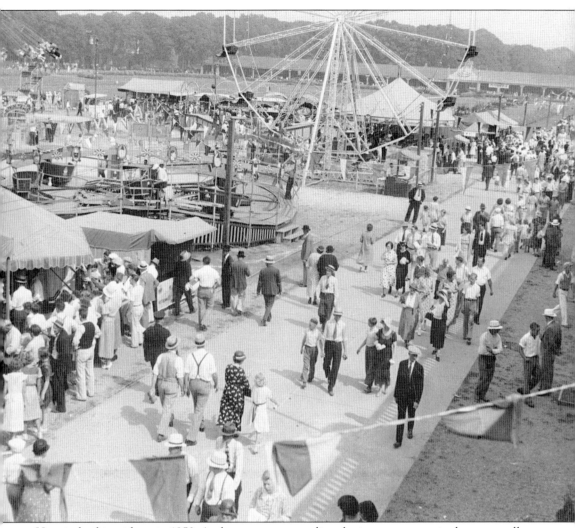

Here is the fair midway in 1950. And no, women attending the it were not required to wear polka dot dresses nor the men required to wear hats and ties; it just seems like everyone attending the fair did. Note the large open area leading to the barns. (Courtesy of the Oregon State Fair.)

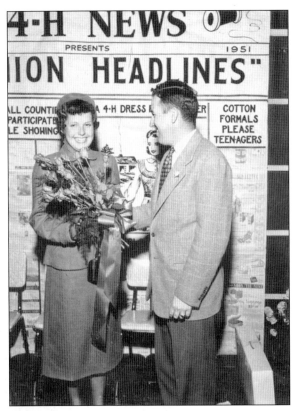

Joanne Thomson, age 15 of Portland, was named Champion in Style Review and received a bouquet of roses at the 1951 fair. (Courtesy of Oregon State University.)

This blue-ribbon group of Champions in Style Review was pictured on stage at the 1951 fair. (Courtesy of Oregon State University.)

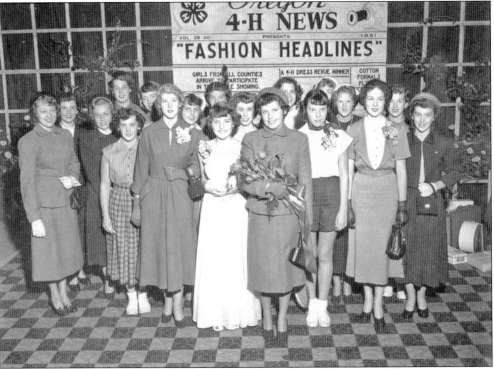

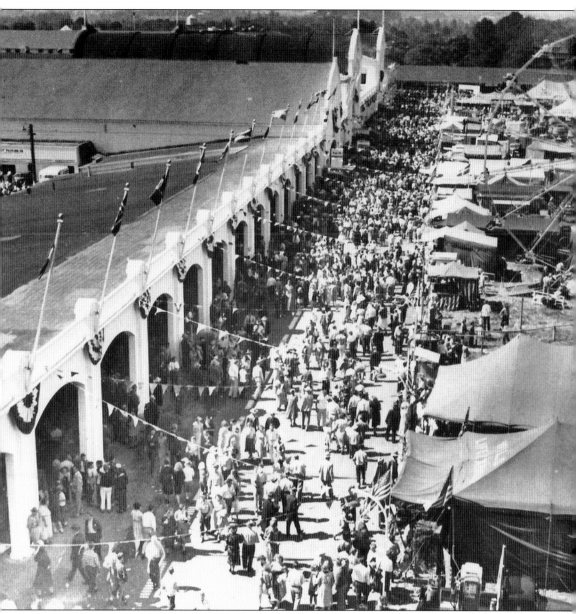

Pictured here around 1950, Restaurant Row was a long group of about a dozen open restaurants run by volunteers from various groups, one of which was St. Vincent's parish of Salem. Hungry fairgoers could find comfortable seating in these big restaurants. "The Row" met the wrecking ball around 1970, about the same time the big roller coaster was removed. (Courtesy of the Oregon State Fair.)

Entertainment at the 1959 fair featured Bob Cosby's All-Star Review. (Courtesy of Oregon Historical Society.)

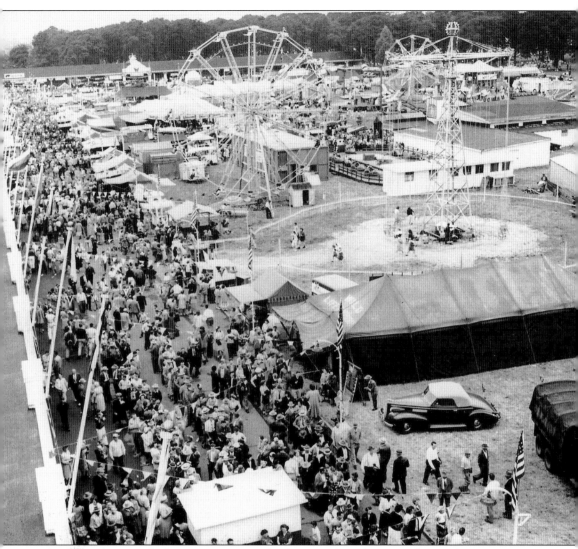

This 1950 photograph shows a portion of the fairgrounds and a great shot of the entrance to Restaurant Row. A few buildings seemed out of place in the middle of the fairgrounds and did not last for many more years. Restaurant Row was torn down in 1968 and the south entrance to the fair was moved about 100 yards further south. (Courtesy of the Oregon Historical Society.)

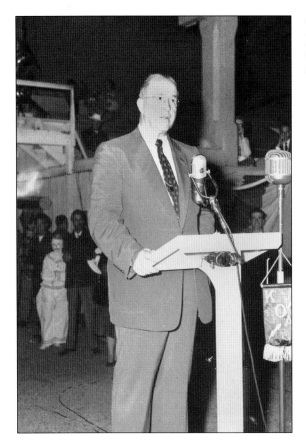

The U.S. Secretary of Agriculture, Ezra Taft Benson, speaks at the 1954 Oregon State Fair. (Courtesy of the Salem Public Library.)

One of the most interesting buildings at the fair, the Poultry Pavillion, dedicated in 1920, is now on the National Register of Historic Places. (Courtesy of the Oregon State Fair.)

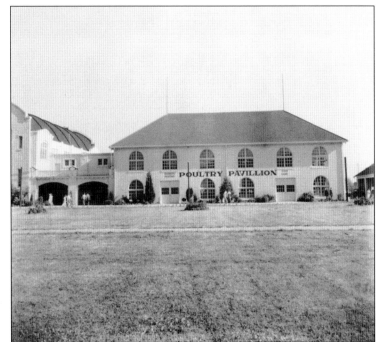

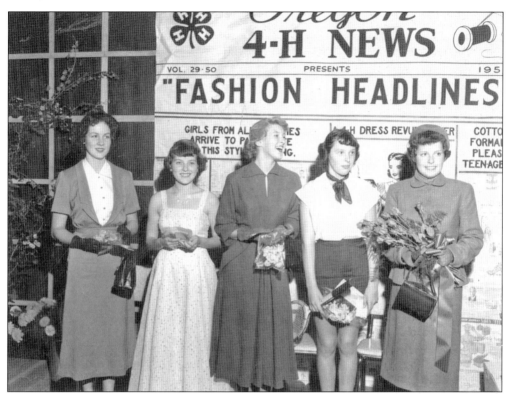

The 4-H brings this view of 1951 fashion winners, all wearing their own creations. Each lady seems to be a winner in a different category. (Courtesy of Oregon State University.)

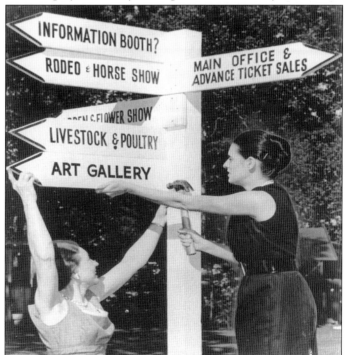

Lillie Ward and Kathaline Bechtell ready a signpost for the 1957 Oregon State Fair. Gov. Robert Holmes cut the ribbon for the 92nd fair. (Courtesy Oregon Historical Society.)

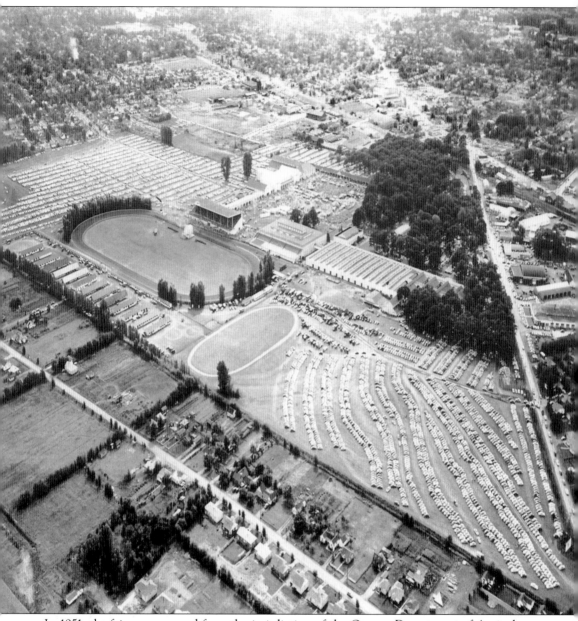

In 1951, the fair was removed from the jurisdiction of the Oregon Department of Agriculture and put under control of the newly created State Fair Commission. This aerial view of the fairgrounds, across Evergreen Street and Silverton Road, was taken in 1954. (Courtesy of the Oregon Historical Society.)

Four

THE 1960s AND 1970s

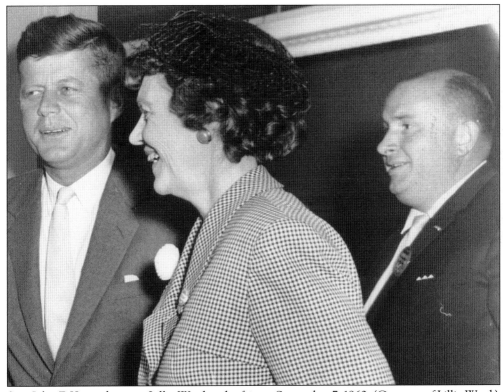

Sen. John F. Kennedy meets Lillie Ward at the fair on September 7, 1960. (Courtesy of Lillie Ward.)

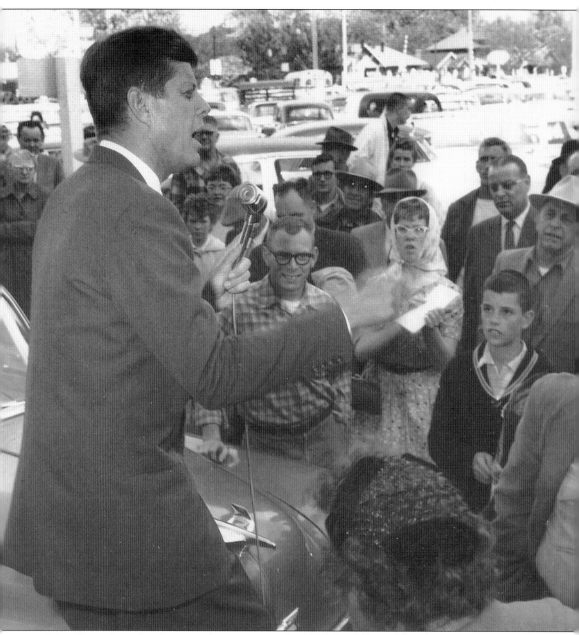

John Kennedy makes his appeal to voters at the 1960 fair. He would not carry Oregon in the election though. He lost to Californian Richard Nixon by 40,658 votes. (Nixon had 408,060 votes to Kennedy's 367,402.) (Courtesy of the Oregon State Fair.)

Kennedy knew he was in one of the closest presidential elections in American history. He also understood the importance of carrying the vote in Oregon, and the easiest way to reach voters in that state was to appear at the Oregon State Fair. (Courtesy of the Oregon State Fair.)

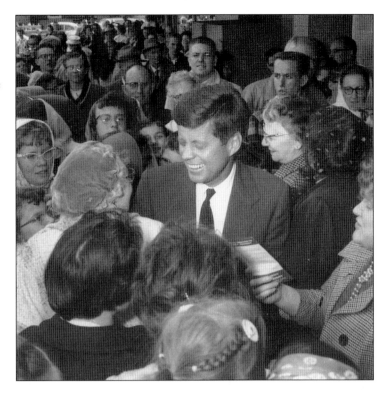

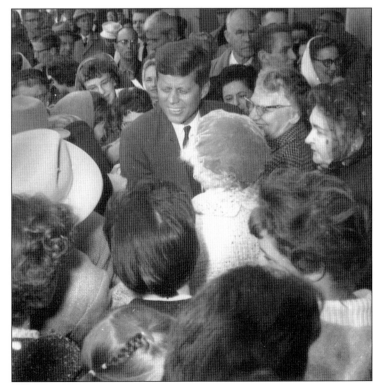

The election of John F. Kennedy in 1960 meant a race to space. A woman from the Space Administration at the fair that year had the author sing a song into a metal tube. The sound was transmitted to a new device called a satellite, which was named Telestar, and came eventually back to the audience. Was such a thing just a dream or had the voice really gone to space and back? (Courtesy of the Oregon State Fair.)

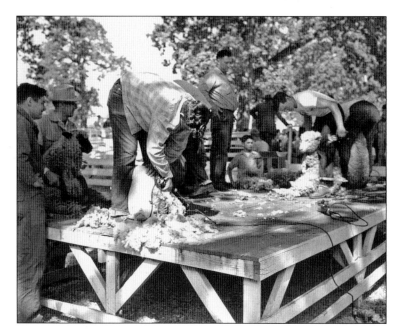

This sheep-shearing competition took place around 1962. It was one of the many events at the fair. (Courtesy of Oregon State University.)

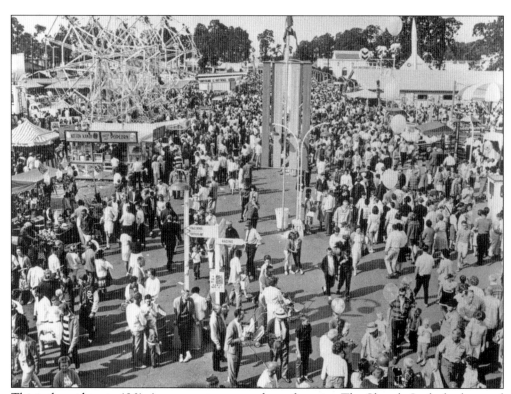

This is the midway in 1961. A poster announces a dance featuring The Chevels. In the background is a 90-foot-tall Thor missile, part of an exhibit announcing America's entrance into the space race. It seems out of place next to balloons and elephants. (Courtesy of the Oregon State Archives.)

Pictured here at the 1965 fair is the Homestead exhibit by the Oregon State Grange. (Courtesy of Lillie Ward.)

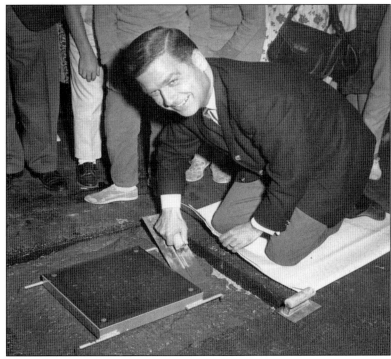

Gov. Mark Hatfield lays footings for the new Women's Pavilion in 1965. He would also light the natural gas flame, a 65-foot landmark. The torch may have been a victim of the 1970s energy crises. (Courtesy of the Oregon State Fair.)

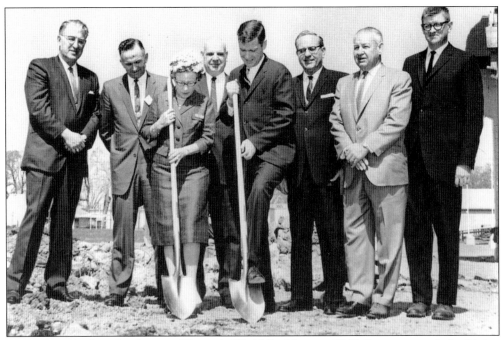

Ground was broken for the new Women's World Building in 1965 (later renamed the Living Arts Building). Holding shovels are Lillie Ward and assistant fair manager Robert Stevens. Also pictured is fair director Howard Maple (second from right). (Courtesy of the Oregon Historical Society.)

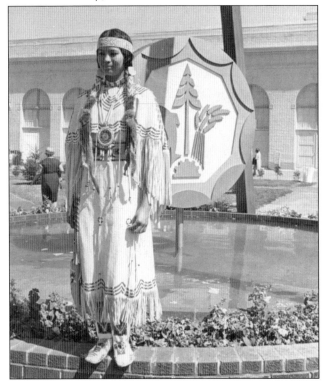

Eunice McAdams dressed as Sacagawea at the Lewis and Clark dedication during the 1965 fair. (Courtesy of the Oregon State Archives.)

In this 1967 photograph, fair manager Bob Stevens explains the situation to Gov. Tom McCall as buildings burn before them. (Courtesy of the Oregon State Fair.)

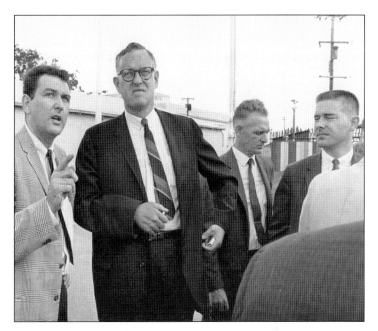

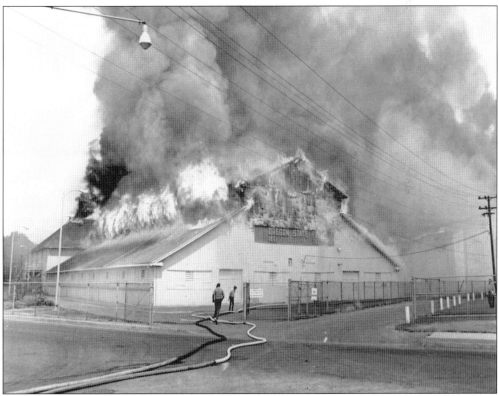

The August 1 fire destroyed the Commercial Exhibits Building and the Natural Resources Building, damaging 40 percent of commercial exhibit space (some exhibits were in other buildings). Governor McCall ordered tents be put up so that the fair could go on. (Courtesy of the Oregon State Fair.)

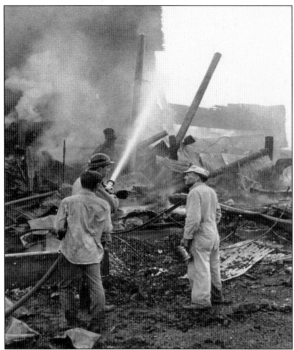

Firemen try to control the fire and limit damage. It has been said by former members of the fair that, on his last day as director, Robert Stevens took the documents and photographs of his years at the fair to a place on the fairgrounds and burned them. The reason for this may have been because he was unhappy about the politics that led to his resignation. If that were true, then it was with his own sense of irony that Stevens closed the most challenging time in the fair's history. As Stevens left the fair on his last day, the future of the event itself was very much in doubt. (Courtesy of the Oregon State Fair.)

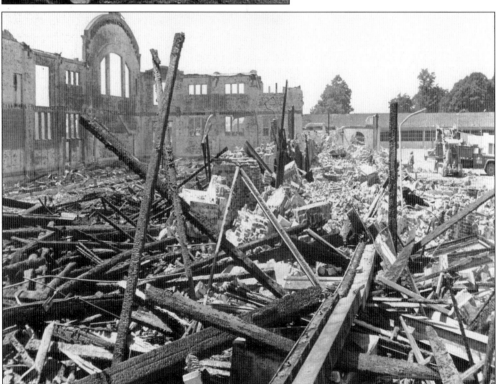

In the aftermath of the fire, E. S. Ritter, a Salem wrecking company, was given the contract to remove debris from the lost buildings. Ritter promised to complete the work in seven days as the 102nd fair was set to begin on August 26. (Courtesy of the Oregon State Fair.)

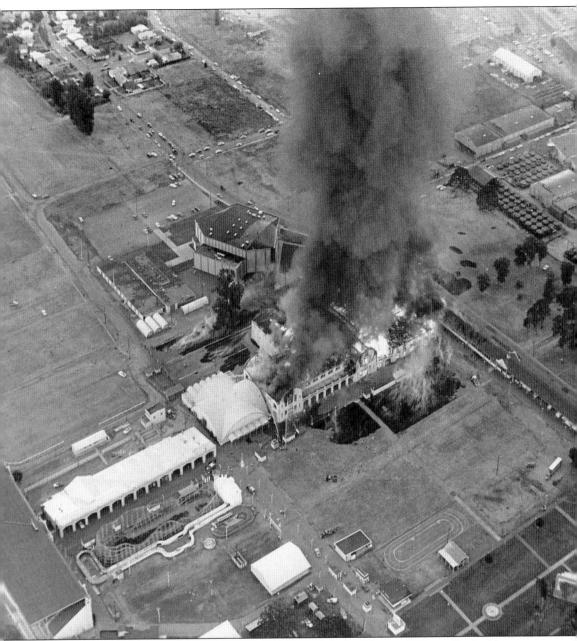

Here is an aerial view of the 1967 fire. A patient from Fairview Training Center who had been on work duty at the fair was later charged with arson and pleaded not guilty by reason of insanity. (Courtesy of the Oregon State Fair.)

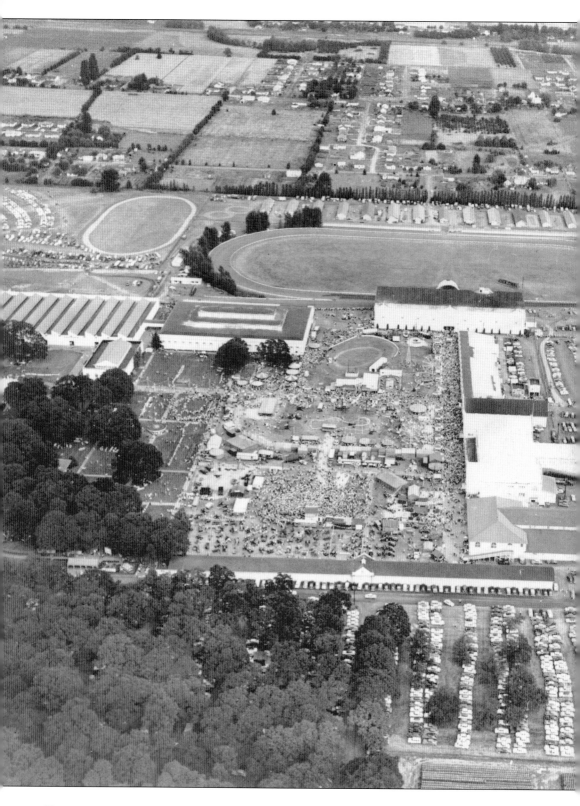

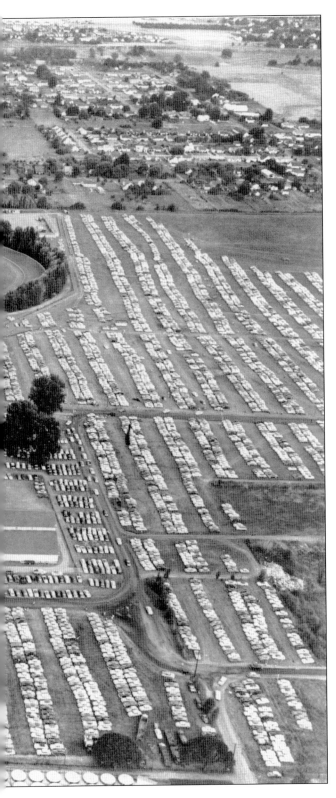

This aerial view of the fair was taken in the 1960s. Note that the large roller coaster stands near Restaurant Row. Most other major buildings have not yet been added. (Courtesy of the Oregon Historical Society.)

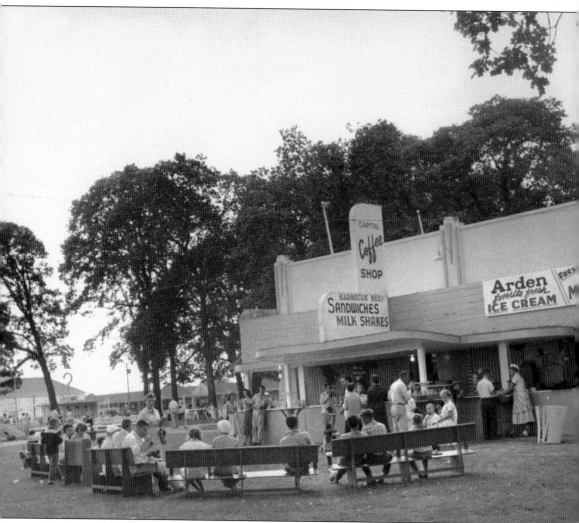

The Capital coffee shop, seen here around 1962, was one of several buildings constructed on the fairgrounds that did not meet the needs of growing crowds or changing fairs. Many of these small buildings took up valuable space and were replaced with much larger facilities. (Courtesy of the Oregon State Archives.)

Mary Archer of LaGrande shows off her winning hat in "The Most Unusual Hat Contest" at the 1969 Oregon State Fair. (Courtesy of the Oregon State Archives.)

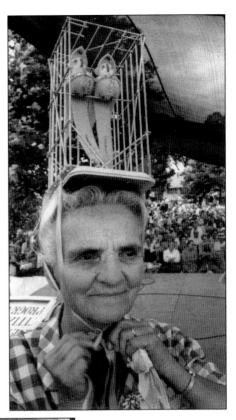

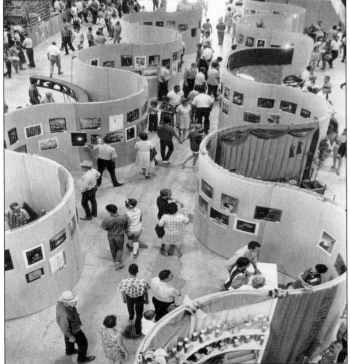

Visitors check out the art exhibit at the 1969 Oregon State Fair. Note the square exhibits and round walls. Hanging square frames on round walls was not the easiest of tasks. A few of these things still exist and continue to confuse fair department coordinators. (Courtesy of the Oregon State Archives.)

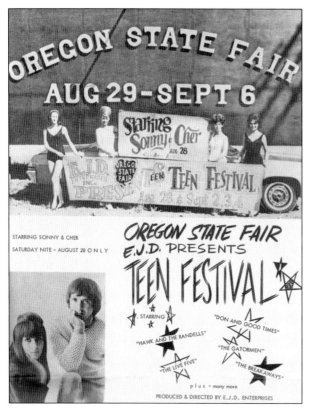

The 1965 fair featured Sonny and Cher as well as a Teen Festival. This was the golden age of the fair; the stars came to be seen. In time, some of these stars may have priced themselves beyond what many fairgoers were willing to pay to see them. (Courtesy of Lillie Ward.)

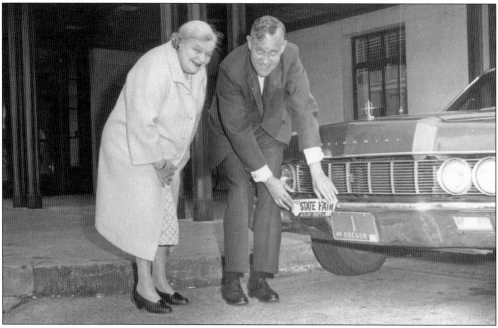

While state representative Grace Peck looks on, Oregon governor Tom McCall, perhaps the fair's best promoter during the 1970s, attaches a state fair bumper sticker to his car in 1970. Note the license plate number. (Courtesy of the Oregon State Archives.)

The legendary state representative Grace Peck adds a fair bumper sticker to her own car in 1970. Representative Peck served in the Oregon Legislature from 1957 to 1975. (Courtesy of the Oregon State Archives.)

The fair was the place for presidential hopefuls. Sen. George McGovern meets with Governor and Mrs. McCall on opening day of the 1971 fair. McGovern lost the race in Oregon by a count of 486,686 for Nixon to 392,760 votes for McGovern. (Courtesy of the Oregon State Archives.)

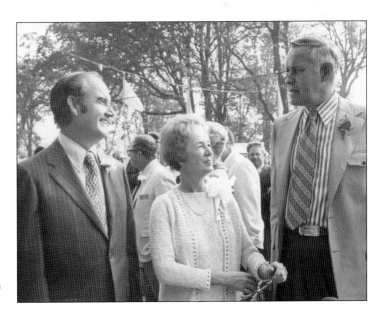

Pictured in 1977 from left to right are Mary Kay Callaghan, Terence Barr, Mrs. William Townsend, and Frederick Heidel, the new members of the fair board. (Courtesy of the *Statesman-Journal*.)

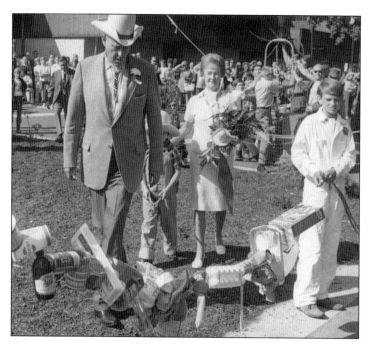

The fair is a place where ideas are born and shown to the world. Governor and Mrs. McCall admire an invention using recycled materials in 1970. (Courtesy of the Oregon State Archives.)

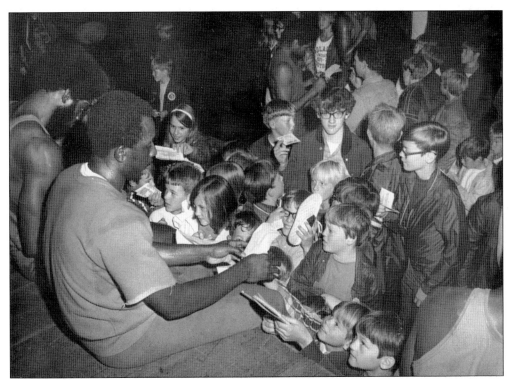

Sidney Wicks and
other members of the
Portland Trailblazers
sign autographs at the
fair in 1975. Having
a presence at the fair
is an inexpensive way
for many organizations
to reach thousands of
people. (Courtesy of the
Oregon State Archives.)

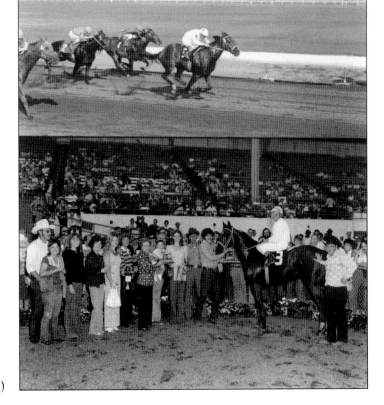

Streakin Bare wins the
Quarter Horse Futurity
in 1976. Considering it
was the 1970s, and the
fact owners have always
had a sense of humor
in naming racehorses,
this is a fitting moniker.
(Courtesy of Lillie Ward.)

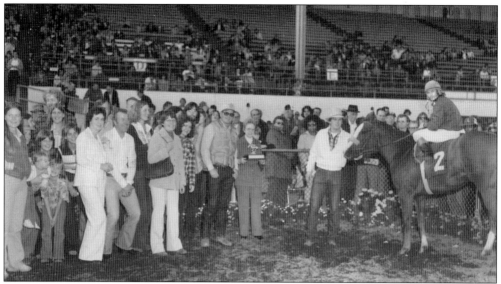

Flashy Chap takes the winner's circle in 1977. Horse racing was a major feature of fairs until it was discontinued in 2001. (Courtesy of Lillie Ward.)

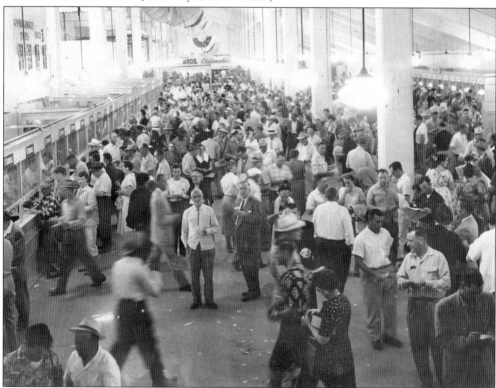

These were nervous moments inside the betting area of the fair around 1970. Gambling was always controversial and was finally discontinued, along with horse racing, in 2002. But horse races also brought some of the finest animals in the world to compete and be seen at the fair. Many fairgoers did not gamble but just went to the races to share in the excitement and appreciate the horses. (Courtesy of the Oregon State Fair.)

Five

THE LILLIE WARD ERA

Lillie Ward (right) and the State Fair Commission brainstorm ideas for the 1965 Oregon State Fair. (Courtesy of Lillie Ward.)

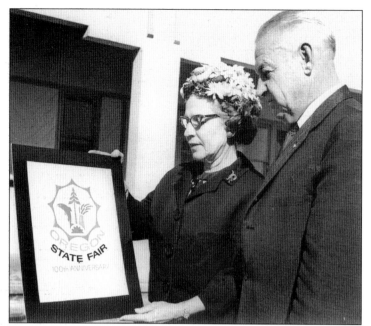

Lillie is seen here with the fair manager, Howard Maple, at the 100th fair in 1961. Maple was a famous football hero in college, served as a coach for both Oregon State University and Willamette University, and coached the Salem Senators baseball team. He resigned as state fair director on March 31, 1967, and was succeeded by Robert Stevens. (Courtesy of the Oregon Historical Society.)

The first-place winner at the September 4, 1966, horse show—Beall's Golden Spike with Joe Biles riding—poses with Lillie. (Courtesy of Lillie Ward.)

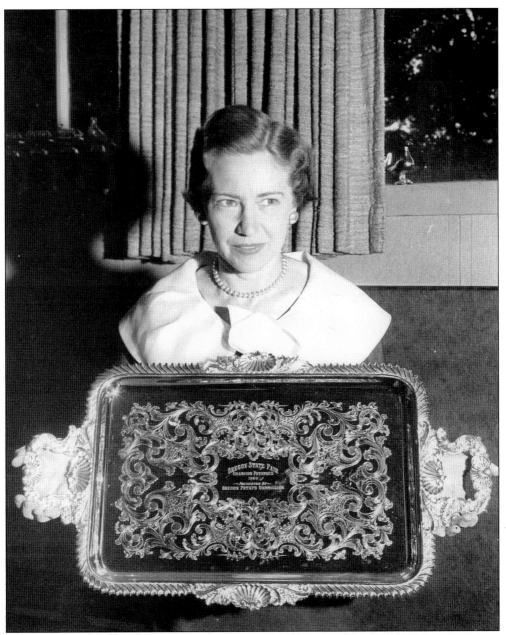

Oregon State Fair secretary Lillie Ward poses with the 1960 award by the Oregon Potato Commission that was given to the fair for the display and promotion of Oregon potatoes. Lillie's patience for the formalities of the fair and her likability made her a good subject for photographers. (Courtesy of Lillie Ward.)

State Fair organize campaign

By LARRY ROBY
Capital Journal Writer

Mary Kay Callaghan, of Salem, has been exhibiting her flowers, vegetables, cooking and sewing at the Oregon State Fair for the past 12 years.

She's afraid now that if the fair doesn't receive a bundle (approximately $4.9 million) for capital construction improvements, this year's fair might be the last.

That would break Mrs. Callaghan's heart and she has set out on a campaign to save the fair.

When she found out that the fair commission and the fair staff couldn't spend state money to lobby to save the fair, she got together with some other concerned Salem residents and formed a non-profit organization, "Operation Fairsaver" which will try to convince the legislature the fair is worth salvaging.

The other principal members of the corporation are civic leader L. B. Day and attorney Bruce Williams, both of Salem.

Every chance she gets, Mrs. Callaghan tells people to go to their local state representatives and senators to tell them how valuable the fair is. This week she sent out letters to the 1,888 exhibitors who brought things to the fair last year.

The corporation has printed blue and white bumper stickers that also are being distributed. They read, "Save Our Oregon State Fair." Mrs. Callaghan and the others would be glad to paste one on your bumper.

Mrs. Callaghan is happy to hear that Gov. Bob Straub has committed himself to improving and saving the fair in Salem.

In his inaugural address, the governor suggested $1.6 million worth of capital construction projects he would like to see started soon at the fairgrounds.

They include a $1.3 million exhibit and food building to replace "Restaurant Row." There also are fund requests that would provide $75,000 for sewer system improvements, $70,000 for a horse trailer parking area and $75,000 for new restrooms.

Straub also wants funds approved for the construction of about 100 new horse stalls at the race track. At one time, it appeared that he might recommend that horse racing be eliminated from the state fair and transferred to Portland.

Now, according to Stafford Hansell, director of the Executive Department, the governor thinks horse racing should remain as part of the fair. That recommendation will be included in the governor's budget, Hansell said.

Straub's emphasis on fair improvements has been coupled with his "get-the-people-back-to-work" idea. He thinks construction at the fairgrounds would be another way immediately to improve declining employment rolls.

Hansell thinks it would be wise for the legislature to act swiftly on the state fair improvements and as far as he is concerned "it's a decision that should not take over a couple of weeks."

Mrs. Callaghan doesn't think the $4.9 million "is asking for the moon."

"After all," she says, "the fair has been self-supporting for the last 113 years."

"I know it is a bad time to be asking for money for the fair," she said.

"But the state owes it to the people of Oregon to continue the fair, and nearly everybody I've talked to seems to love the fair."

Capital Journal

Salem, Ore., Thursday, Jan. 16, 1975, Sec. 2, Page 11

With the future of the fair in doubt and many calling for it to be discontinued, Mary Kay Callaghan formed a nonprofit organization named Operation Fairsaver to save the event in 1975. She was joined in her efforts by L. B. Day and Salem attorney Bruce Williams. (Courtesy of the *Statesman Journal*.)

Lillie presents Lee Snowden of Monmouth and James Phillips of Silverton the awards for largest sunflower and tallest corn at the 1959 fair. (Courtesy of Lillie Ward.)

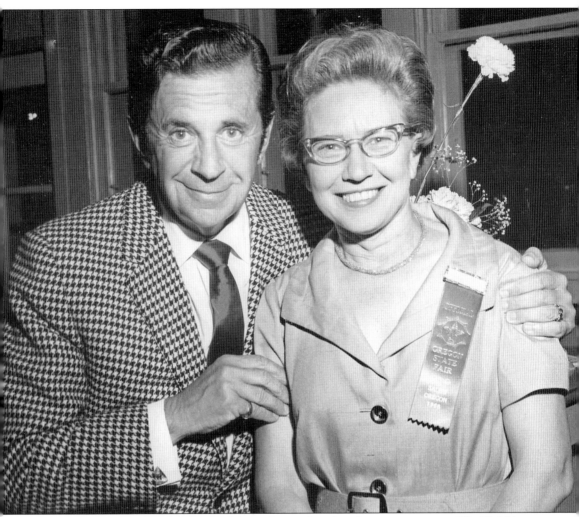

This picture of Lillie Ward with actor Morey Amsterdam, best known as a star on *The Dick Van Dyke Show*, was taken on August 27, 1968. The Lillie Ward era seems to have been the "golden age of the fair," and many stars wrote Lillie after appearing at the event to thank her. Some sent their photographs, but this book only shows those stars who actually had their pictures taken at the fair. (Courtesy of Lillie Ward.)

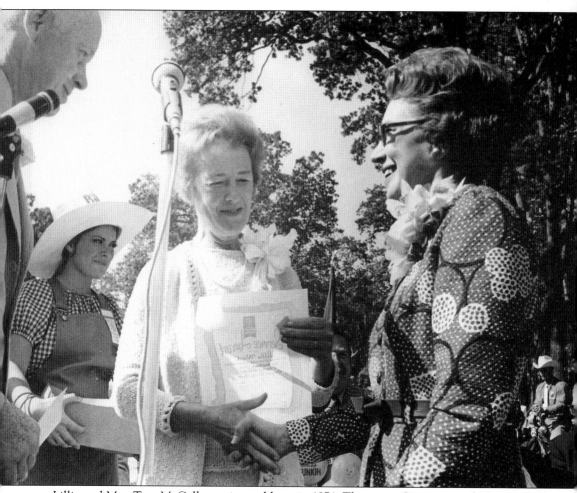

Lillie and Mrs. Tom McCall are pictured here in 1974. That year, Governor and Mrs. McCall arrived at the fair in a horse-drawn wagon. (Courtesy of Lillie Ward.)

STATE OF OREGON
DEPARTMENT OF STATE

SALEM 97310

CLAY MYERS
SECRETARY OF STATE

GEORGE H. BELL
HAROLD F. PHILLIPPE
ASSISTANTS

Appointment as Emergency Interim Successor
Asst. Manager, Oregon State Fair
Appointment by

Mrs. Ray Ward Mr. Robert L. Stevens
¹⁻ ⁻⁻ ⁻⁻⁻⁻⁻ ⁻⁻ ⁻ No. Interim Successor Number
Salem, Oregon 97303 Three

Dear Mrs. Ward:

We have received from the state official shown above a notice of
your appointment as his interim successor.

Pursuant to ORS chapter 236, this information has been noted and filed
in the office of the Secretary of State.

Enclosed you will find an Oath of Office which should be executed
before a notary public and returned to this office for filing.

If, in the future, you should have a change of address, we would
greatly appreciate being informed of your new address. If you have
any questions regarding this matter, please let us know.

Sincerely,

Jack F. Thompson, Director
Elections Division

JFT:cm
Enclosure

This is the official letter appointing Lillie Ward as Oregon State Fair director. The letter is signed by Jack Thompson, the Oregon Elections director and one of the finest minds in Oregon politics. He was a former classmate of Mark Hatfield at Willamette University. He would later go on to serve as project manager for the Capitol Wing Addition Project, which added the senate and house wings to the state capitol. (Courtesy of Lillie Ward.)

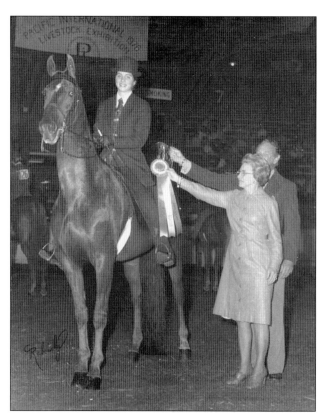

Fair director Lillie Ward congratulates a horse show winner in 1976. Despite the fact that there is no longer horse racing at the fair, fairgoers can still find many very competitive horse shows in the arena, often at no charge. (Courtesy of Lillie Ward.)

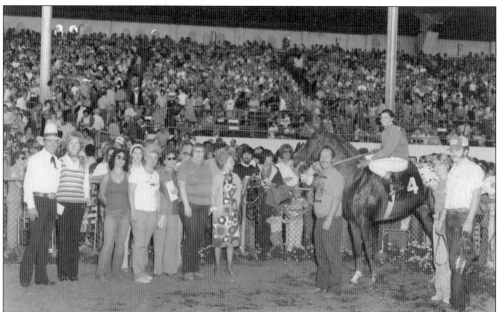

Lillie Ward congratulates C. Whited and R. Tucker and their horse, Hasty Pass, after a win on September 5, 1977. Horse racing brought stars of another kind to the fair and an excitement that could not be found anywhere else. Even people who did not gamble could enjoy a race and appreciate the great animals competing. (Courtesy of Lillie Ward.)

Sheri Christianson is pictured here during a performance at the 1976 Oregon State Fair. She later sent this photograph to Lillie Ward in appreciation. Dozens of major stars performed and sent their autographed pictures to Lillie. (Courtesy of the Oregon State Fair.)

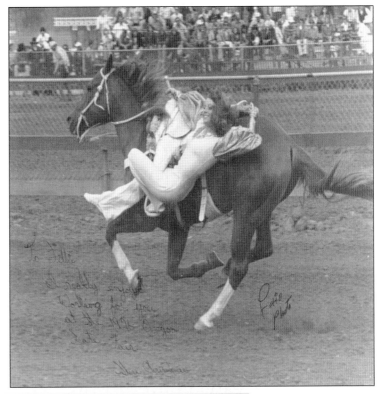

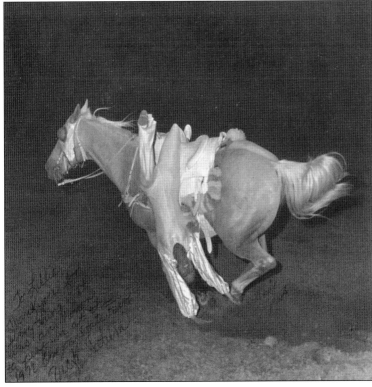

Performer Vicki Tatum showed the crowd a new way to ride a horse in her 1976 show. (Courtesy of the Oregon State Fair.)

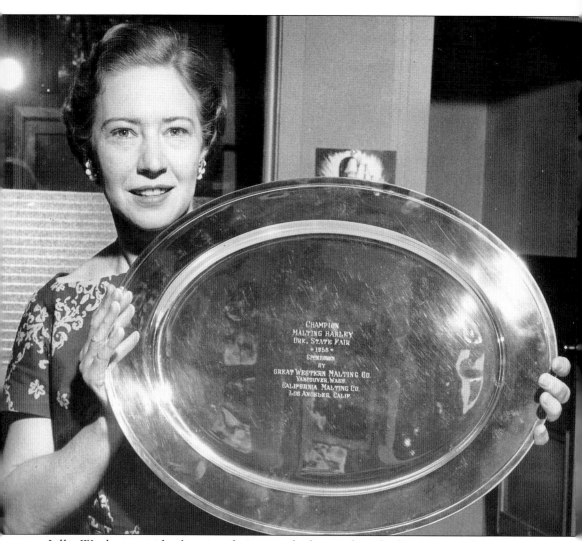

Lillie Ward poses with silver award given to the best malting barley grown in Oregon, which in 1958 was the Great Western Malting Company. (Courtesy of Lillie Ward.)

Six

THE L. B. DAY ERA

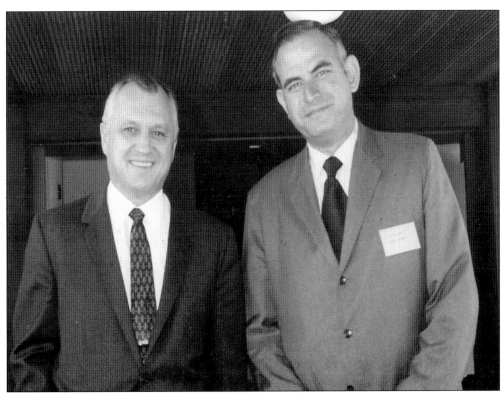

L. B. Day, pictured here at the fair in 1975, was director of the Oregon Department of Environmental Quality in 1972 when he dangled from a hot air balloon 85 feet above the ground to plant a small Douglas fir on top of a tent used for exhibits. (Courtesy of Mrs. L. B. Day.)

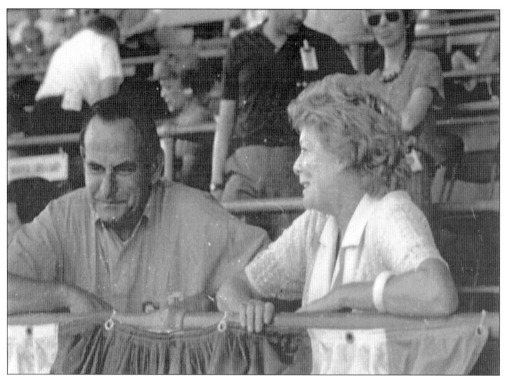

L. B. Day is pictured at the racetrack joking with Secretary of State Norma Paulas. A picture is worth a thousand words, and these tell a lot about the humor and personality of L. B. Day. In 1974, Day was appointed to the Oregon State Senate to fill a vacancy by Marion County commissioners Harry Carson, Pat McCarthy, and Walt Heine. (Both courtesy of Mrs. L. B. Day.)

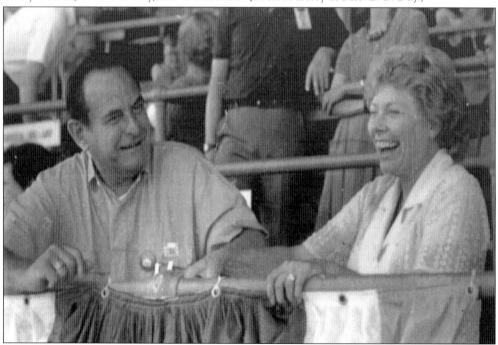

State senator L. B. Day (left) poses with promoter Ed Daughtery (right). For more than 30 years, Daughtery (EJD) brought some of the finest entertainers in America to the fair. (Courtesy of Mrs. L. B. Day.)

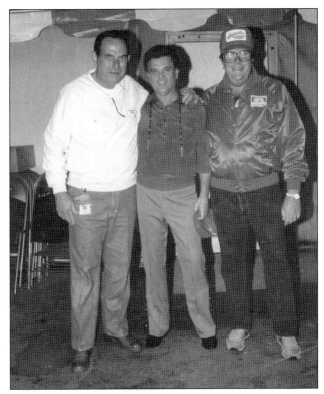

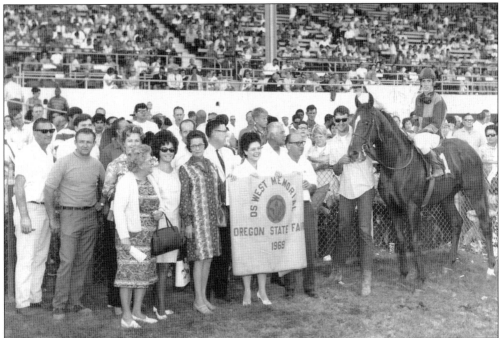

Cindy Day welcomes a horse and jockey to the winner's circle in 1969. It was the generosity and support of Cindy in providing these rare photographs that helped make this book possible. (Courtesy of Mrs. L. B. Day.)

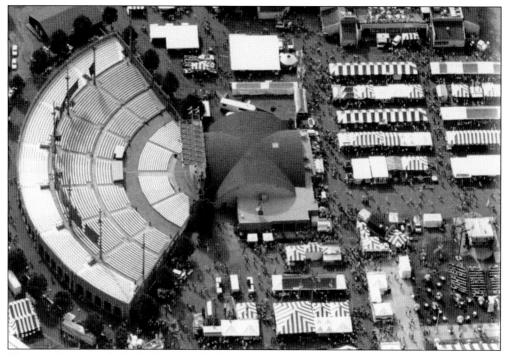

This aerial view of the L. B. Day Amphitheatre was taken during the 1995 fair. (Courtesy of the Oregon State Fair.)

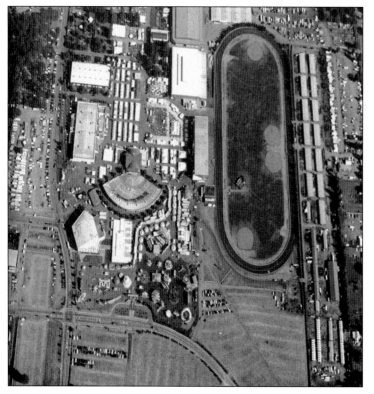

This aerial view of the L. B. Day Amphitheatre seems to have been taken before the fair opened for the day. The L. B. Day Amphitheatre, pictured here in 1995, was built in 1987 on the site of the old pavilion, 10 years after that building was destroyed. (Courtesy of the Oregon State Fair.)

Seven

FAMILIAR FACES

Oregon author Jerry Easterling, a longtime writer for the *Statesman-Journal*, brought his energy and his *Country Chaff* books to the fair for more than 15 years. A leader of the Oregon Authors, he offered an enthusiasm that gave books a special place at the fair. (Author's collection.)

Karen Hill of Sheridan poses with two Canadian Mounties in 1999. Few six-legged horses have appeared at the fair. (Courtesy of the Oregon State Fair.)

This photograph of the author was taken in 1979. In 1978, when the author first brought poetry books that he'd written to the fair, things quickly changed, and he discovered he was not just promoting books but also poetry and literacy in general. This was the real goal—to show people that books and literature could and should have a place at the fair. The effort gained the attention of such noted local authors as Jerry Easterling and Irene Bennett Brown. It was they, along with many other great Oregon authors like Maynard Dawson, who brought the first Oregon Author's table to the fair in 1986. Joe Brown brought his contributions to the group in 1995. (Author's collection.)

Lauanne Krauzer, 1981 Miss Oregon World, poses with a live tiger at the Wildlife Safari exhibit. Along with the author, Krauzer appeared in four stage shows that featured poetry and humor at the 1981 fair. (Courtesy of Wildlife Safari.)

Young photographer Angela Heine poses in front of the Poetry Display at the 1999 fair. She was one of thousands of young people who grew up at the fair, setting up displays, entering her work, and seeing how the great show was set up, run, and quickly taken down again. The fair has made a significant impact on the lives of many young people. Poetry was an experimental division at the 1988 Oregon State Fair, and the model has been used by many other county fairs in Oregon and by fairs and festivals all over the United States. Even in Israel, poetry contests are organized after the Oregon State Fair model. During the first years of poetry at the event, it honored many Oregon poets such as Winifred Layton, Penny Avila, Anita Hamm, Sister Helena Brand, Dr. Joseph Soldati, and future Oregon poet laureate Lawson Inada. (Author's collection.)

1989 OREGON STATE FAIR

APPEARING ON THE L.B. DAY AMPHITHEATRE STAGE

Johnny Cash and June Carter
August 25—5 & 8 p.m.

The Everly Brothers
August 26—2 & 8 p.m.

Tanya Tucker
August 27—2 & 8 p.m.

Kenny G
August 28—5 & 8 p.m.

George Reinmiller Super Big Band
August 29—1 p.m.

Nu Shooz
The Crazy 8's
August 29—5 & 8 p.m.

Kenny Loggins
August 30—5 & 8 p.m.

The Oak Ridge Boys
August 31-September 1—5 & 8 p.m.

Paul Revere and The Raiders
September 2—2 & 8 p.m.

Wiliams & Ree
September 3—2 & 8 p.m.

The Tom Grant Band
The Michael Harrison Band
The Street Corner Singers
September 4—2 & 8 p.m.

Horse Racing • International Food Fair • Carnival

Here is the Premium Book from the 1989 fair whose theme was "Through the Eyes of a Child." Entertainment that year featured Johnny Cash and June Carter, The Oakridge Boys, Tanya Tucker, and Paul Revere and the Raiders. Don. G. Hillman, a former operations director for the fair, was appointed director in August 1989. (Author's collection.)

Eight

THE GREAT CHOCOLATE CAKE DEBATE

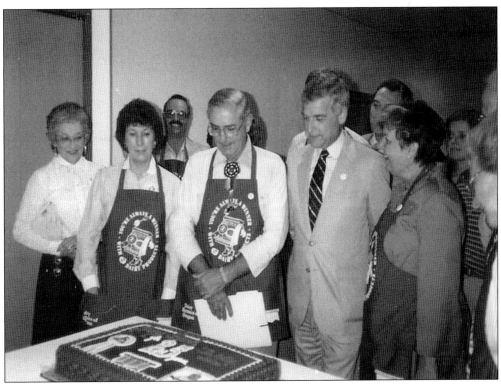

In 1959, Mark Hatfield was elected governor of Oregon, and Gerry Frank began serving as chocolate cake judge at the Oregon State Fair. This 1984 photograph was taken during Gerry Frank's 25th anniversary of judging chocolate cakes. Frank is pictured here with Sen. Mark Hatfield and Gov. Victor Atiyheh. (Courtesy of Gerry Frank.)

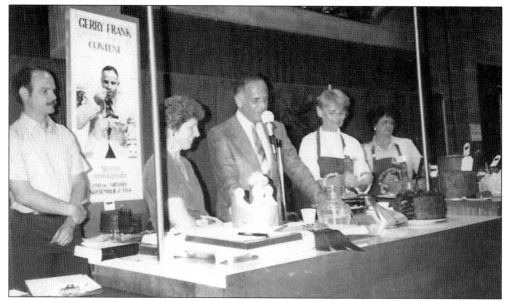

Gerry Frank begins to judge chocolate cakes for what was the biggest show at the home economics department for 25 years. Beside him is Coralee Cox, who has served many years with the fair and was one of the reasons the department has been so successful. (Courtesy of Gerry Frank.)

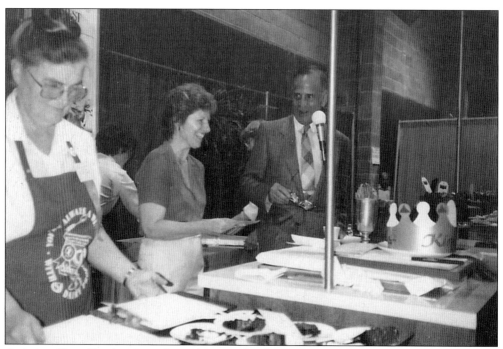

Assisting Gerry Frank is Janet Lee, who served as home economics superintendent for 23 years before retiring in 1998. For many people that worked in the home economics department (including the author), it was an experience and an honor to have served under Janet and to have seen her calm leadership in a department that often has many events changing very quickly. (Courtesy of Gerry Frank.)

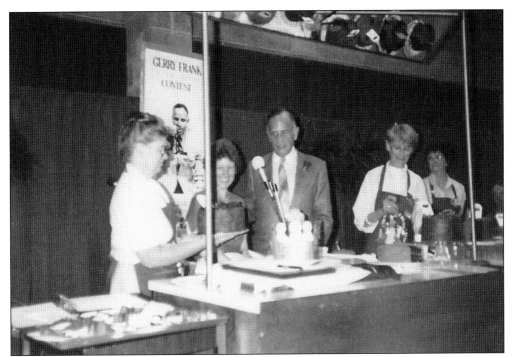

With a nervous competitor watching, another cake is offered up for judging in 1984. (Courtesy of Gerry Frank.)

It pays to know chocolate cake. This young man at the 2001 fair has the answer to Gerry Frank's quiz-show question. (Courtesy of Gerry Frank.)

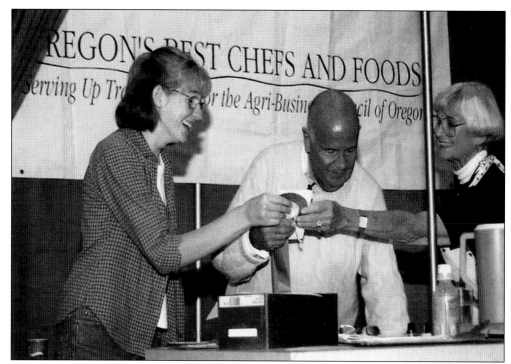

Coralee Cox and Gerry Frank award a blue ribbon to the 2001 winner. The prize is among the most coveted at the fair. (Courtesy of Gerry Frank.)

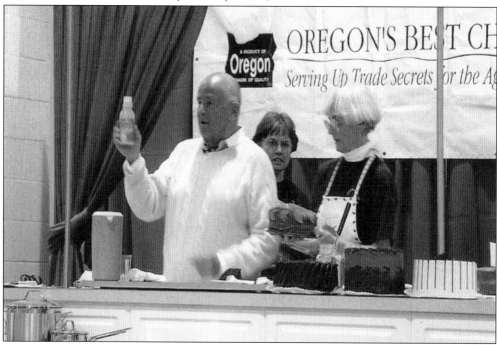

In this 2001 photograph, Gerry Frank gives contestants tips for winning as well as how to sample dozens of chocolate cakes and keep on eating. At some fairs, he has judged over 100 cakes. (Courtesy of Gerry Frank.)

Nine

ANIMALS

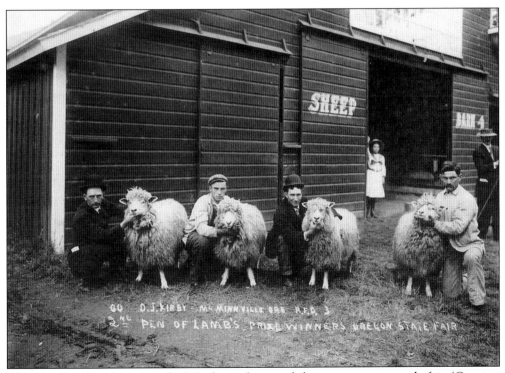

This photograph, taken around 1890, shows sheep and their owners at an early fair. (Courtesy of the Oregon State Fair.)

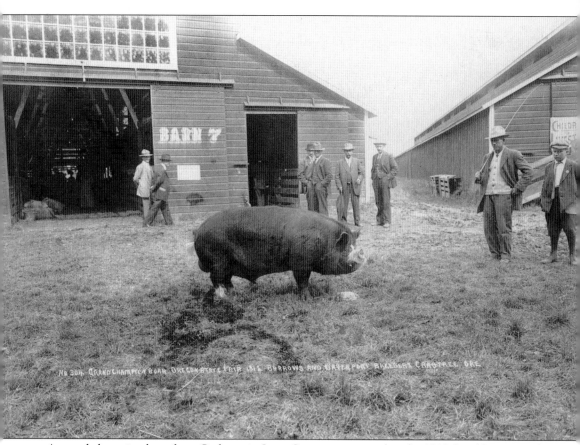

A grand champion boar from Crabtree in Linn County is pictured at the 1920 fair. (Courtesy of the Oregon State Archives.)

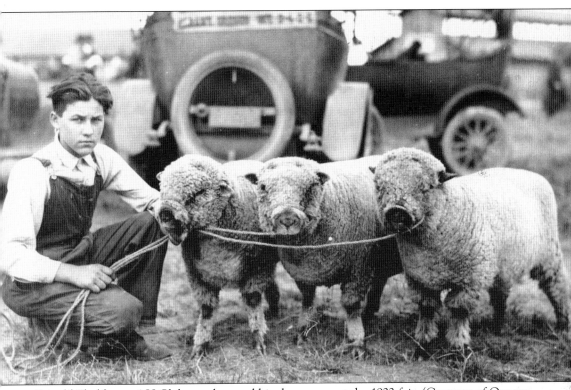

Donald Sheldon, a 4-H Club member, and his sheep pose at the 1922 fair. (Courtesy of Oregon State University.)

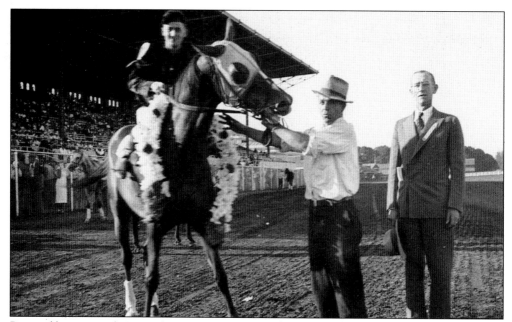

Pictured here around 1930 is the Governor's Handicap winner and Salem mayor Kahn. (Courtesy of the Oregon State Library.)

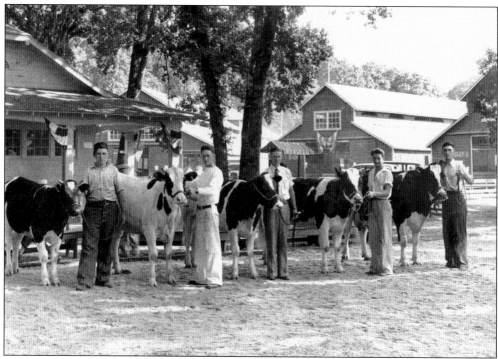

Competitors and dairy cows pose in front of old barns around 1930. (Courtesy of Oregon State University.)

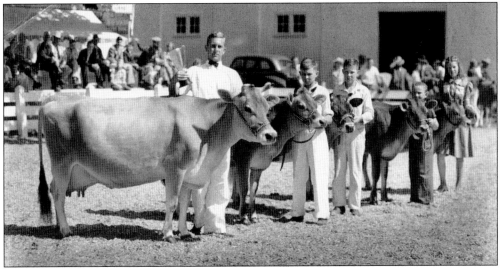

The business side of the fair is critical to the economy. Class of Producing Dairy cows pose at the 1938 fair. (Courtesy of Oregon State University.)

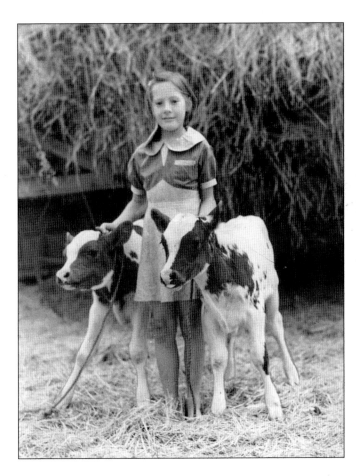

Treva Falk of Halsey stands between two calves she is showing at the 1939 fair. (Courtesy of the Oregon State Archives.)

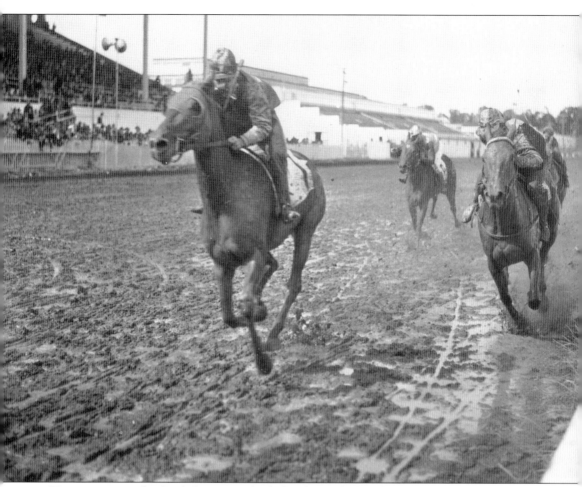

Horses power to the finish line as mud splashes beneath their hoofs about 1940. The Oregon rains have often considered themselves invited guests of the fair and have a wonderful attendance record. (Courtesy of the Oregon State Archives.)

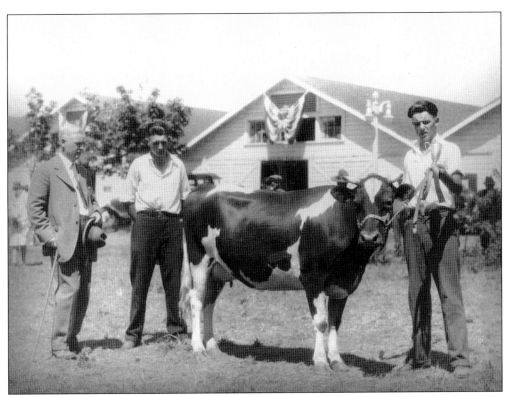

Pictured with this prize-winning dairy cow at the 1940 fair from left to right are general manager of Pacific International Livestock Exposition O. M. Plummer, Fritz Schantz of Tillamook County, and Hans Leuthold of Tillamook County. (Courtesy of Oregon State University.)

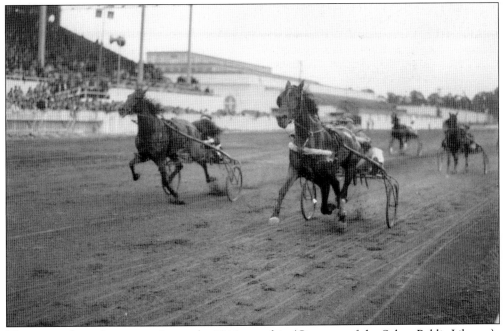

This image shows harness racing at the 1946 state fair. (Courtesy of the Salem Public Library.)

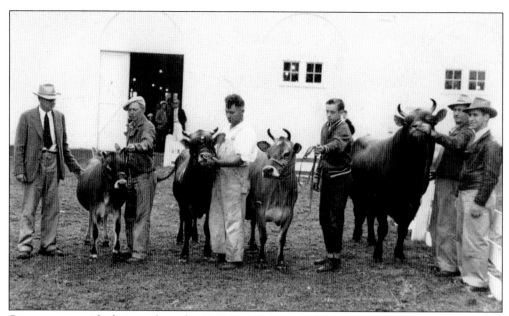

Six men pose with their cattle at the 1950 fair. (Courtesy of the Oregon State Archives.)

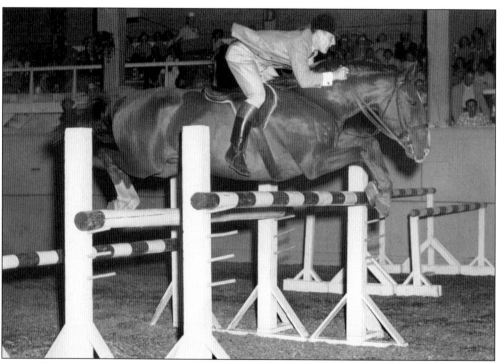

Harry Chapman and his horse Spendthrift compete in a jumping competition at the 1956 fair. (Courtesy of the Oregon State Archives.)

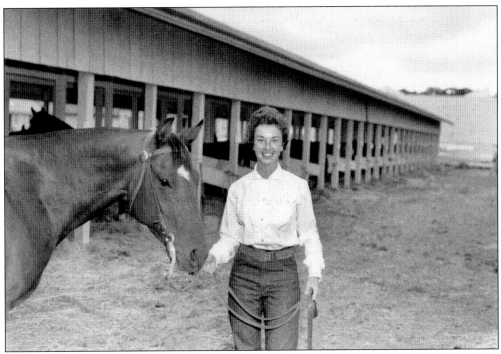

Gwen Guthrie of Prineville poses with her horse after passing trials at the 1959 fair. (Courtesy of Oregon State University.)

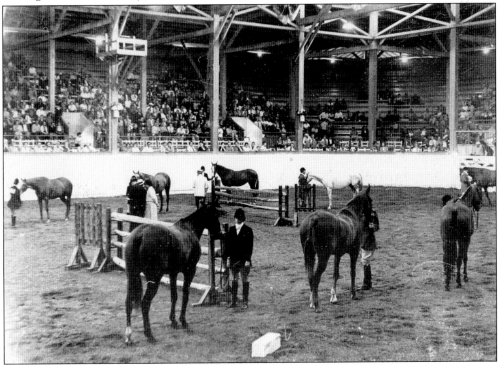

Jockeys prepare their horses for a steeplechase event in the 1960s. (Courtesy of the Oregon State Archives.)

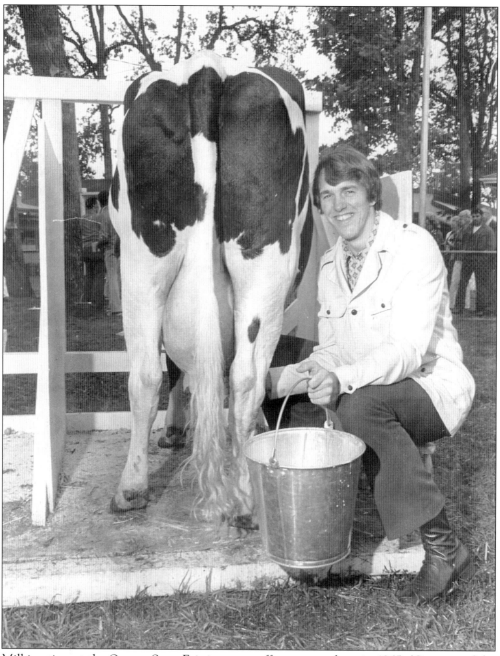

Milking time at the Oregon State Fair is a team effort, as seen here in 1965. (Courtesy of the Salem Public Library.)

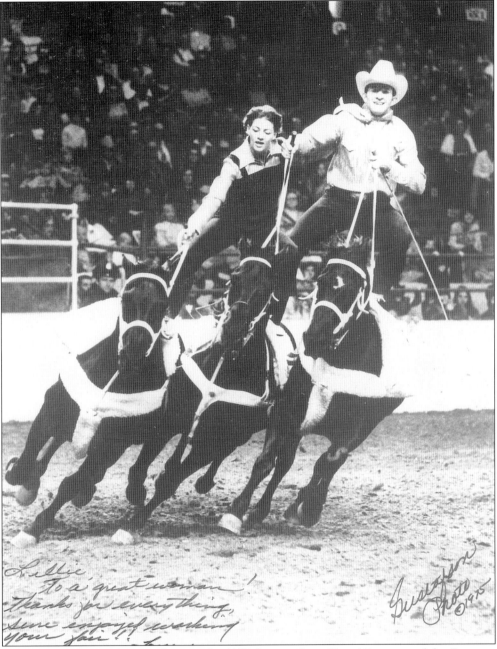

Jerry and Maureen Olsen perform at the 1975 Oregon State Fair. (Courtesy of the Oregon State Fair.)

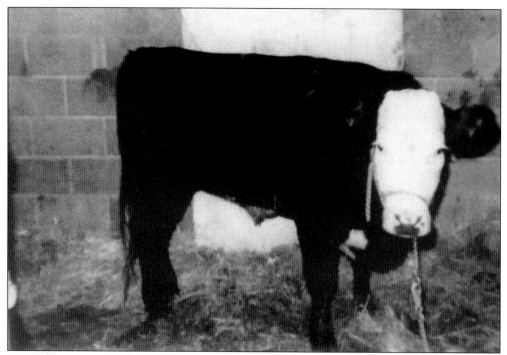

Of the thousands of bulls to go through the fair, Rufus was by far the most famous. On opening day in 1979, Rufus escaped from his handlers and swam the Willamette River to West Salem. He went on to serve as the fair's mascot for seven years, greeting visitors from behind two layers of fencing until suffering a fatal leg injury in 1988. (Courtesy of Scott Bernards.)

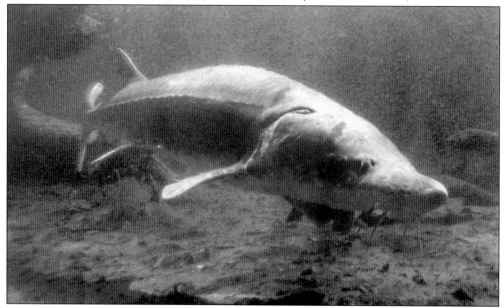

Herman the Sturgeon, Oregon's most famous fish, was a fixture at the Oregon State Fair for nearly 50 years. According to the Oregon Department of Fish and Wildlife, Herman "retired" in the mid-1980s. Groups hope to raise $500,000 to build a new aquarium at the fair for Herman and other native fish. (Courtesy of the Oregon Department of Fish and Wildlife.)

Ten

2006: A TIME CAPSULE

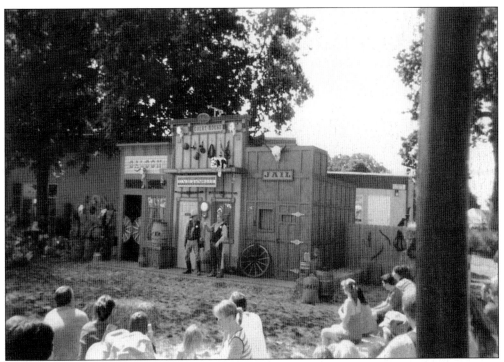

In 2006, the Oregon State Fair was put under the Oregon State Parks Department. It was a fortunate turn of events, for the department had decades of experience in welcoming the public and caring for state-owned facilities. The 2006 Oregon State Fair was considered by many to be one of the most successful in decades. Free parking and dozens of free shows that families could enjoy (like this one) had fairgoers apparently much happier with the fair than they had been in years. People seemed to relax and enjoy the experience of just being at that fair. It also had a new manager in Dave Koellermeier. Pictured here are the tiny sets where free shows portraying the Wild West were acted out. (Author's collection.)

Here is the 2006 Oregon wine competition, which featured professional wineries and 44 of the finest amateur winemakers in Oregon. Wine and beer competitions are a huge success at the state fair and serve to promote new industries in Oregon. Oregon wines have won some of the highest awards in the world in recent years, and the ingredients for many of the beers made in the United States have always been grown in the Willamette Valley. It was only natural for an emerging microbrew industry to develop world-class beers from local crops. And the best of both are available at the fair. (Author's collection.)

Here artist Patty Manning demonstrates calligraphy at the 2006 fair. Having won many awards for her craft, Patty brought it to the fair in 1990. The small departments, like calligraphy, are an important part of the fair. If a craft or an art has visual appeal, it has a good chance of winning a place at the event. When poetry was brought to the fair in 1978, it was Patty's calligraphy on the book covers that helped sell the books. (Author's collection.)

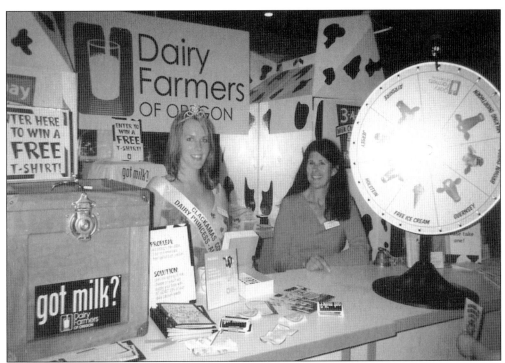

A dairy princess from Clackamas County works at the 2006 Dairy Farmers of Oregon booth. Not enough can be said about the contributions of the Oregon Dairy Farmers to the fair. They have done a good job of promoting their industry and the fair itself and have also kept costs down for families so that they can enjoy the foods the farmers produce at the fair. (Author's collection.)

Oregon author and former fair board member Mary Kay Callaghan formed a nonprofit organization to save the Oregon State Fair in 1975. Here she is pictured at the 2006 Oregon Author's table. Despite the pageantry, the controversy, and near certainty of heavy rains during fair time, the Oregon State Fair is for 10 days each year the most exciting place in Oregon. (Author's collection.)